LANDSCAPES

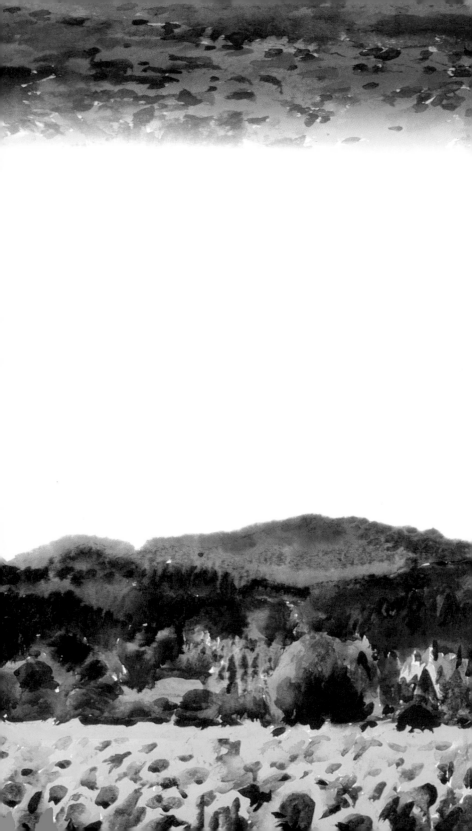

LANDSCAPES

BARRON'S

CONTENTS

THE MEDIUM AND THE LANDSCAPE

Painting, from its beginnings, has made use of the landscape as a point of reference for establishing the subject matter. Over the course of time, landscape painting was transferred from walls to other more manageable surfaces such as papyrus and parchment.
Used as a backdrop to historic, religious, or everyday scenes or simply as an allegory of nature, the landscape has been adapted to each age, through the use of new techniques and pictorial mediums.

The Earliest Landscapes Were Painted on Stone

Before the invention of writing, prehistoric peoples would paint on the walls of their caves scenes depicting activities that were vital for their survival, particularly hunting. They would use natural pigments (umbers, charcoal, and ground minerals) bound together with animal fats to represent the shapes of the animals and their surroundings. Cave paintings presented a totally spatial view. Not knowing the rules of perspective, these early artists depicted the objects on the same plane, using differences in size as their only reference. Surpris-

The earliest paintings were made on the cave walls using mineral pigments that were sometimes bound with animal and vegetable fat.

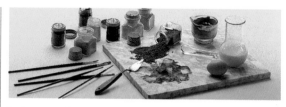

ingly, some of these paintings have survived down to the present day.

Egyptian paintings also included landscapes as a background to the stories they told. The most common medium used by the Egyptians on the papyrus was similar to what we now call tempera, a pigment bound with either with egg yolk or glue.

The Medieval Landscape

Medieval painting, together with the cultural heritage of the Western World, was confined to the monasteries. Monks became copyists and miniaturists who illustrated the codices and copied Bibles in which they included explanatory scenes. These tiny images accompanying the text were painted on parchment, a fine, cut and bound sheet of skin. The basic pictorial technique

Material for tempera painting.

used for these miniatures was tempera. For the murals in churches, fresco was used.

The landscape formed the background for these brightly colored scenes, revealing a great capacity for synthesis and imagination. Medieval landscape scenes were of an instructional nature, an attempt to inform a mostly illiterate population. They therefore presented everything in a simplified manner, using a single plane without the use of perspective.

Page from The Book of Hours, *a medieval manuscript with miniatures painted in tempera.*

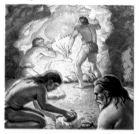

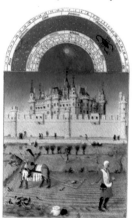

The Renaissance, a Technical Revolution

With the arrival of the Renaissance, art emerged from the convents, a new merchant class financed the construction of important buildings, and the age of the great palaces and early baroque cathedrals began.

Artists, grouped into guilds, began to produce pictorial works commissioned by the nobility and also by the wealthiest classes of society—traders and moneylenders.

Painting evolved rapidly with the introduction of oil paints from the Low Countries. Technical developments such as the invention of perspective and anatomy enabled painting to reproduce nature with a hitherto unknown degree of realism.

Landscape painting was subdivided into urban landscapes as the background to everyday scenes and rural landscape as the background to mystical, religious, or hunting scenes.

Patrice Giordo, La Sortie de la Maison. (Second version). Acrylic on canvas.
Pierre Alechinsky. Je Suis Loin. Acrylic on canvas.
Two versions of contemporary landscape painting.

Twentieth-Century Landscapes

Since the age of Impressionism, avant-garde movements such as Post-Impressionism, Fauvism, Cubism, Expressionism and Surrealism have followed each other at lightning speed, and the landscape has adapted to all of these movements as one of the main subjects to be interpreted.

Nowadays we cannot say that a single movement exists...twentieth-century landscape puts the legacy of the old masters into practice via numerous modern approaches.

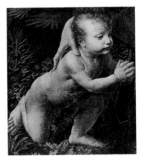

Leonardo da Vinci, The Lady of the Rocks. Oils and perspective brought important developments to the representation of landscape.

W. Turner, The Road to Ubierto. Romanticism introduced us to the earliest abstract ideas through landscape, and with Turner, watercolors came back into their own.

From the French Academy to the Impressionists

In Paris, the academy laid down strict rules concerning both composition and proportion. Landscape painting was no exception to this academic pressure and artists were required to paint landscapes virtually from memory.

The contribution of the Impressionists, both to the theme of the landscape and to the pictorial technique used, was decisive for this break with academic standards. Breaking away from the strict guidelines of the academy, the Impressionist painters produced highly creative landscapes painted directly from nature itself, with the color being applied directly on the canvas. Their work was rejected by contemporary critics, but was soon to be accepted by younger generations of artists.

Vincent Van Gogh, Jardin de Arles. Impressionism led the painter to break away from academic ideals both in expression and in the use of color.

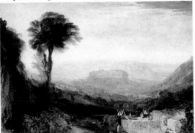

MORE INFORMATION
Landscape composition **p. 28**

MIXING COLORS

In landscapes, chromatic design has an enormous influence over the final result, through the use of the basic harmonic ranges, cool, warm, or neutral.
The mastery of color in landscape painting is an ability acquired through much practice. We will review such subjects as color theory when applied to various approaches to landscape painting.

Color Theory Applied to the Subject

When the artist is faced with a particular landscape, the first thing he or she is aware of, long before forms or details, is the color. When a particular subject is to be painted, irrespective of the technique used, the first consideration is the color that will make up the chromaticism of the subject. This means that, although the subject possesses its own chromaticism, the artist is free to use any combination of colors necessary for his or her interpretation of the subject.

Tonal Gradation

Regardless of the technique used when painting a landscape, the color has a certain tonal and covering power, so it is important to know the chromatic limitations of each color being used.

Tonal evaluation can be observed directly from the landscape, i.e., from the point of view of the observer. For example, an expanse of land varies in color from the foreground back to the horizon. So do the different elements of the landscape, such as trees, rocks, etc., together with the weather conditions that also affect the overall chromaticism.

Within the same landscape a single color can have different intensities that alter its tone.

As distance increases, colors tend to lose luminosity.

Using the Palette

It often occurs during landscape painting that the color complexity leads the artist to drastically reduce the range used, and therefore the exciting relationships of color are gradually lost.

After the initial colors have been applied, the palette should be used constantly to mix the necessary tones and colors. In this way the chromaticism progresses at the same pace as the development of the forms.

The different hues on the palette are obtained by gradually adding small amounts of the color to be blended in. For example, cerulean blue acquires a greenish tinge if a small amount of yellow is added, and if a small amount of crimson is added to the resulting mixture, the result will be a bluish kaki.

Yellows, ochers, reds, siennas, umbers, and crimsons form the warm ranges.

Greens and reds, oranges and blues are complementary colors. When mixed, they produce grays.

Different gradations of color obtained on the palette.

The Medium and the Landscape
Mixing Colors
Details and Spontaneity in Painting

9

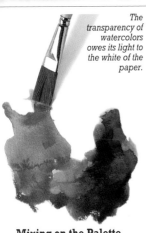

The transparency of watercolors owes its light to the white of the paper.

Mixing on the Palette

Whatever the technique may be, the palette is the perfect "test-bench" for experimenting with colors, be they water-based colors or oils. Mixing on the palette enables us to find exactly the color we require. As we saw in the previous chapter, there are three basic ranges (warm, cool, and neutral) within which all harmonic ranges can be obtained.

Within each range, the chromaticism obtained may include colors that actually belong to other ranges. In the case of oil painting, the color obtained on the palette will not change when applied to the painting. Water-based paints, on the other hand, will dry differently on the painting than on the palette. Transparent watercolor allows what is beneath it to show through, be it the paper of palette or an earlier application of paint on the canvas.

Initial development of forms.

Different types of roughing-out.

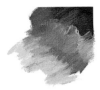

Spontaneous Mixing on the Canvas

The colors in landscape painting can be applied freely and mixed directly on the canvas.

For this style of "direct" painting, a wide range of colors is unnecessary. Just the primary colors and a few earth colors are usually sufficient. Rapid, or *alla prima* painting, is highly practical for small works or sketches. The colors are almost always mixed directly on the canvas, which is an advantage as far as speed is concerned, although it does reduce the potential for introducing different hues. Rapid painting brings a feeling of energy and excitement to the painting and is a useful technique for rapidly synthesizing the forms and colors of the landscape.

Color and Brushstroke

The mixture of colors applied with the brush should develop the necessary color combinations for the subject. When working on a landscape, the forms should gradually come to resemble those of the subject, from the initial roughing out of the canvas to the finished work. Color and brushstroke are determined by the type of brush. Different brushes blend the colors in different ways, depending on whether they use a hog's hair brush or a softer type.

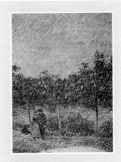

Painting mixed directly with the background color.

The Impressionist Painters

The Impressionist painters broke away from the academic ideal that required a rather theatrical view of nature with an affected, finicky use of color.
The Impressionists' view of color was not the chromatic mixture as it appeared in the painting, but rather the overall impression caused on the retina by the juxtaposing colors.
This landscape in oils by Pisarro is an excellent example.

MORE INFORMATION

Mixing colors **p. 8**
Water: rivers and ponds **p. 62**

DETAILS AND SPONTANEITY IN PAINTING

The subject of landscapes in painting is by no means exhausted, nor does it belong to any particular style or period. Throughout the history of painting, landscapes have been present on the easels of many artists. In the beginning, landscapes were painted entirely in the artist's studio. It was not until the nineteenth century, with the Realists and later the Impressionists, that artists began to venture out of doors with their canvases and easels to capture nature directly, painting with the same light and atmosphere that illuminated the subject.

Quick Painting and Expression

In landscape painting the initial stages are just as important as its further development and completion. Right from the beginning, when the artists are assessing the composition, they are preparing the way in which the painting is to develop.

An interesting way of starting a landscape is to work from memory. In this way, although the artist will later have to refer to the subject, this effort to summarize the subject will enable him or her to organize the elements in the composition.

Expression in landscape painting reflects the artist's command of technique and understanding of form. It is always advisable to make use of a sketchbook in order to work out various solutions to the problem at hand.

Continuous exercise in quick painting, with the discipline it involves, is one of the best approaches to landscape painting.

Ramón Sanvisens, Windy Day. *This detail is an eloquent example of the artist's pictorial virtuosity as reflected in its expression.*

Pastels, a Quick Technique

Halfway between painting and drawing, is the technique of painting with pastels. It is

Being a dry medium, pastels possess characteristics akin to drawing.

Compared with drawing, however, pastels provide greater plastic and chromatic potential.

an ideal medium for painting quick, spontaneous landscapes.

Pastels are a dry medium and thus have many of the characteristics of charcoal or pencil.

Pastel painting first involves applying the overall masses of color and then evaluating the resulting tones and hues. The color should not be blended together or stumped, as this would detract from its luminosity. Being an opaque medium, subsequent layers can be applied.

Once the work is finished, it is advisable to store it in a portfolio that has onionskin separators so that the colors do not get smudged.

This painting by Claude Monet reveals the artist's pastel technique.

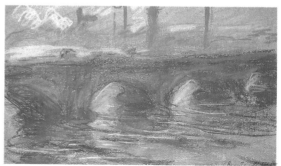

After the initial application of paint, new layers of color are added.

Many of the areas originally painted should be left untouched to maintain their initial spontaneity.

Leaving the Painted Areas Untouched

Whichever pictorial technique you are using, you must always bear in mind all the stages involved in depciting a landscape.

After the initial roughing-out, additional layers of paint are applied. An experienced painter knows that many of the original areas should be left unaltered, since this initial work on the canvas is more spontaneous both in color and form. For example, the fact that the initial tones used for painting the greenery of the countryside are not quite right will require corrections, but the experienced artist will try to add new layers of paint only when strictly necessary.

In the case of watercolor painting, not overworking the painted areas is essential if we want to preserve the trans-

MORE INFORMATION

Middle ground, general plane (differences between planes) **p. 32**
River and pond vegetation **p. 64**

Pastels and Fauvism

Pastel was a medium commonly used by the Fauvist painters. It allowed them to see the final result without waiting for it to dry and, being a dry medium, colors could be superimposed immediately, allowing underlying layers of complementary colors to show through subsequent layers, thus lending vibrancy to the work.

parency and luminosity inherent to this technique.

Letting the Colors Show Through

In landscape painting, the way in which the work is constructed reveals how the artist interprets the subject. Allowing certain carefully chosen background colors to show through gives strength and

A clear example of how the background "breathes" through the subsequent layers.

spontaneity to the painting. For example, a green expanse of land with ocher and orange colored grass will be more vibrant if, before applying the green tones, the area of dry grass has been painted with ochers and oranges.

The paint on the canvas must be allowed to show through in places so that when different layers of paint are added, a feeling of depth and atmosphere is created.

Watercolors, Atmosphere Without Detail

Watercolor is one of the most luminous of pictorial techniques. White is never used in this medium because it is provided by the white of the paper. The transparency of the medium provides luminosity through subsequent applications of color, while new tones are being created at the same time.

One basic technique is to work on a dampened paper which forces the color areas to blend together, thus creating imprecise combinations of blended colors. For a more precise technique, working on a dry surface is recommended. Combining both techniques is ideal for painting landscapes, as a dampened background is ideal for skies, while a dry background is better for painting details.

A watercolor painting that shows the qualities of the medium: luminosity, transparency, and chromaticism.

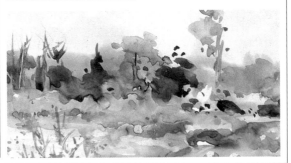

DIFFERENT TECHNIQUES FOR PAINTING TREES

Standing out against the horizon line, creating planes, and adorning mountains, trees are an essential component of landscape painting.

Pencil, ink, oils, acrylics, and pastels are the most common materials used for landscape painting. Each contributes its particular qualities and potential to depict, as far as possible, the characteristics of the subject.

Using a Pencil

The different gradations obtainable with a lead pencil lend fluency and spontaneity to the subject.

When drawing trees, the range of grays used is equivalent to the tonal range of colors.

The first step when using any medium is to compose the subject. This is usually done in pencil or charcoal. The main lines summarize the overall layout that is to be developed, alternating gradated grays and lines that outline the forms. After the preliminary drawing, the major lines are further emphasized and the elements given more defined structure.

Once the form has been fully defined, the volume is created by the gradation of grays, thus alternating light and shadow, and bringing out the different textures of the subject. The way light and shadows are applied to the bark, the protruding roots, and the largest

Different lines produced with different pencils or solid leads.

Detail of a landscape drawn in pencil.

limbs should be different from the manner in which light and shadows are handled in the leafy areas. This difference is an important factor in highlighting textural identities.

Ink

India ink can be used alone or diluted, producing two totally different effects.

It can be applied with a brush or pen nib. The lines left by these are different and rep-

resent two entirely distinct ways of working.

A good approach of the subject can be developed using a nib and varying the intensity of the dark areas by way of tightly drawn hatched (crossed) lines. The closer the hatched lines are together, the darker the area will become. Texture is created by the use of many different cominations of lines.

India ink is used in a diluted watercolor technique sometimes characterized by brush application of light and dark washes, or is used at full strength to obtain solid black areas.

Watercolors

Watercolor is one of the most delicate techniques, as the artist is always dependent

Detail of a landscape with ink washes.

Different types of India ink and nibs available on the market.

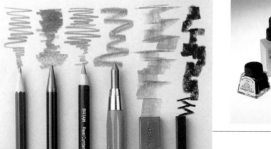

upon the underlying colors. When painting a tree in watercolors, the initial design is essential to prevent any background colors from interfering with the space reserved for it. Trees are seldom formed by solid volumes and it is often possible to see much of the background colors through the branches.

Watercolor can be applied on a wet or dry surface. On a totally dry surface, the brush can draw precise lines without them becoming distorted. So when painting a tree against a light colored background, it is necessary to wait for the paint to dry before adding branches and other details. The foliage of the tree can be painted on a dampened surface.

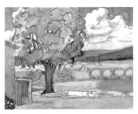

Ink gouache.

Increase of contrast and reinforcement of shadows.

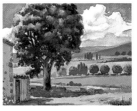

Pastels

Pastels are an opaque medium and so are perfect for working light over dark. As a dry medium, it is similar to drawing. Because of the wide range of colors available in a set of pastels, any mixing of the colors is unnecessary.

The layout can be done with a light-colored pastel, even over a surface that has already been painted. The color applied last replaces all of the underlying colors. The reason for avoiding any mixing of colors is to maintain the spontaneity of direct application of the colors made possible by this medium.

Acrylics

Acrylics are a quick and effective medium for landscape painting. Its fast drying ability and permanence make this polymerized resin one of the most versatile tools available to the artist.

Acrylics can produce transparent effects like those of watercolors or dense, opaque colors like oils.

Seeing these trees, it is obvious why many consider pastels halfway between drawing and painting.

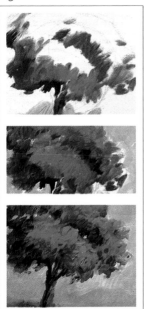

Different stages in painting a tree in acrylics.

Rendering a tree with acrylics can be done directly with the paint itself, and, as it dries quickly, other colors can be almost immediately applied. The colors originally applied to the canvas will not interfere with the new layer.

Despite its rapid drying, acrylic can be used in much the same way as oils when it comes to mixing and blending colors. The difference is that this medium uses water as a solvent.

Medieval Synthesis

Medieval painting appears naive and simple, although works such as this one reveal the synthesis with which the trees in the background have been painted. In *The Burial of Christ* (1333), Simone Martini uses tempera paint (pigment and egg) to paint the tree-tops with dark tones that stand out against the reddish background.

MORE INFORMATION

Trees in the landscape **p. 50**
Drawing trees in the landscape: branches and leaves **p. 52**

EVALUATING PLANES IN PASTELS

Pastel is pure pigment with glue as a binding agent. This is why it stands halfway between drawing and painting as far as technique is concerned. It is, however, an important pictorial medium when considering its plastic results.

Landscapes in pastels are rewarding in that no time is required for drying, thus allowing the artist to apply additional colors immediately. Pastel requires no mixing on the paper; only gentle blending with a paper stump.

A Fast Technique

Speed and brilliance are the chief advantages of pastel painting. The approach for a landscape in pastel colors is the same as for any other technique: beginning with an initial sketch or layout. As pastel contains chalk, it is a completely opaque medium and can therefore be used on any colored paper, even if it is dark.

Roughing-out can be done in any color as it will be totally concealed by the subsequent layers of pastel. Pastel colors can be applied directly, either using the edge with the stick laid flat on the paper, or with the tip.

The opacity of pastel allows you to paint one color over another.

The fingers are the best tool for working with pastel.

Pastel allows you to superimpose opaque planes, allowing the background to show through.

Building up the Painting

Although it is possible to paint directly with pastel colors, the potential for superimposing different layers and planes leads us to an entirely different pictorial approach.

Once the landscape has been laid out, the artist can apply the colors of the most important planes while delaying the details in the foreground. As pastel colors are a dry and opaque medium, such detail can be left until the last moment. For instance, if there is a thicket in the middle ground and some houses situated behind it, the houses should be painted first and then the thicket, at the same time allowing the more distant planes to show through.

Different sticks and pieces of pastel.

Evaluating the Background of the Paper

The opacity of pastel allows you to paint light over dark; therefore, a wide variety of paper colors can be utilized in this medium. The color of the paper becomes one more color in the

Example of pastel application to canvas:
A. rubbed pastel.
B. rubbed into the pores of the paper.
C. rubbed and stumped.
D. linear markings.

A

B

C

D

Warm range on a warm background. The background color is as important as the color of the painting itself.

Cool range on a cool background. Note how the background contributes to the tones.

The Density of Pastel

In this landscape, painted in 1912, Paul Séusier presents a painting with three planes that are clearly defined by their colors. Pastel is an ideal medium for superimposing colors, although in this case the artist has preferred to restrict his use of colors in order to let the color of the paper to show through.

composition of the landscape and can therefore be used as the chromatic base for the theme, allowing the color of the paper to reverberate through the colors that have been applied subsequently. In this way, a range of colors complementary to the color of the paper lends vibrancy to the entire composition. For example, red or orange paper acts as a complementary color when painting a landscape in cool colors.

From General Plane to Foreground

We have seen how the color of the paper can play an important part in the chromaticism of the painting. In the same way, the initial painting of the background can also show through the subsequently applied colors. Pastel applied lightly to the sky, mountains, and open spaces can act as a base for superimposing planes without losing any of the original spontaneity. In order to protect the initial colors, a layer of pastel fixative should be applied to them.

Building up a painting begins with the initial underpainting on the canvas and continues with the development of the most important elements. The foreground as well as the middle ground contain such important details as branches, grass, etc.

Pastel as a Technique for Rapid Painting

For making quick sketches of landscapes, pastel is an ideal medium that requires no particular preparation. Being an instant medium, it can be used without the consideration of drying time. One of the quickest ways of covering large surfaces such as the sky, mountains, valleys, thickets, etc., is to lay the pastel stick flat on the paper. This technique avoids detail and allows one to concentrate on the color and the composition.

This sequence of images illustrates how, beginning with an unfocussed image of the subject, the masses of color are synthesized.

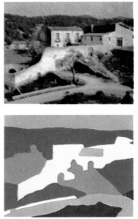

Great care should be taken to keep the pastels clean. After each use, rub the pastel on a piece of cloth to remove any remains of other colors.

The sticks of pastel should be cleaned after every use to remove other colors.

How to Store Your Paintings

Contrary to its appearance, pastel is a very stable medium if treated carefully; so when a work is finished, either in the studio or outdoors, it should be stored in a folder separated by sheets of wax paper or vellum. No fixative should be applied to the final surface as it tends to turn the pigments dull and lifeless.

| MORE INFORMATION |

Rural buildings, distant planes **p. 56**

Different planes and depth **p. 76**

WATERCOLORS AND THE LANDSCAPE

One of the pictorial mediums most suited to landscape painting due to its immediacy and chromatic potential is watercolor.

From Dürer down to the present day, this medium has been adapted to every pictorial challenge because of its flexibility and transparent brilliance. It was not, however, considered "true" painting until the last century.

As regards landscape painting, watercolor is invaluable for making preliminary sketches. This is not an easy technique, in that the transparent nature of the medium tends to reveal every underlying stroke of paint, including the mistakes.

However, it is undoubtedly one of the most beautiful pictorial mediums ever developed.

Basic paintbox for the watercolorist.

Glycerine for slowing the drying process, alcohol for accelerating it.

Materials

Certain basic materials are necessary for painting in watercolors: watercolor paints (in tubs, tubes, or liquid form), paper, a work surface, Scotch® tape and thumbtacks, watercolor brushes, a jar for the water, and a sponge and dampening paper.

Other materials include glycerine (a few drops in the watercolor slows down the drying time), wax for resisting paint in certain areas (areas covered in wax will protect the paper from watercolor paints), a knife or other pointed object (for scratching the paper to create different effects), salt (a few grains on the wet surface creates a mottled effect) and a hair dryer to speed up the drying process.

A complete paintbox for outdoor work.

A Spontaneous yet Complex Medium

The medium of watercolor is, of course, water and gum arabic. This pigment is dissolved and bound into a substance that becomes hardened if the water evaporates. It can be used later by adding water; the amount of water added will vary depending on the density required.

Watercolors are almost totally transparent and can be applied on wet or on dry surfaces, or, by using both techniques, can achieve a variety of effects.

The transparent nature of this medium reveals all the underlying layers of paint. It is one of the few techniques in which correction is impossible.

Charles Reid, Toulouse-Lautrec. *For the first modern painters, watercolor was the quickest and most direct medium. Artists would constantly venture out of portable studios with their light equipment to take notes directly from nature.*

Plywood
board

A suitable
box

Sheet of
watercolor
paper

Tray for brushes
and tubed paints

Palette for
tubed paint

Collapsible metal
stool

Plastic jar for
water

Collapsible
tripod-type
easel

Glass for
water

Sponge

Turner and the Landscape

Turner produced this grove of trees with a restrained use of color, allowing for maximal use of the white of the paper, while at the same time employing the dry method in certain areas.

A cautionary note: avoid ruining a painting opportunity just because a small but critical element, such as tape or water, was not included in your watercolor kit.

Painting on Dry Paper

If the paper is allowed to dry after being taped down, it will become taut as it contracts with the evaporation of water. Watercolor can then be applied with far more accuracy than on a dampened surface. The dry technique also gives the artist far more control of fine detail and texture.

Combining a wet technique for the sky and a drier technique for the trees and foreground can produce an exciting result.

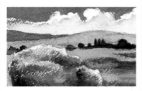

Frottage is carried out on a dry surface, using a very small quantity of paint on the brush.

Landscapes are particularly suited to this technique, as both the composition and the drawing allow much greater flexibility than in a portrait or still life.

Painting a landscape on wet paper.

After the underpainting dries, careful brushwork is possible.

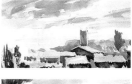

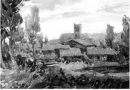

Finished landscape. Both techniques, watercolor on wet paper and watercolor on dry paper, have been used.

How to open up whites; a dry brush applied to the wet background absorbs the color.

Painting on Wet Paper

Painting on a surface wetted with a brush or sponge allows the paint to expand and spread over the entire area. The water should not be allowed to form puddles; the paper is porous enough to absorb the necessary amount of water.

Drawing is basic to watercolor painting, and should be done before wetting the paper. Once it is wet and attached to a rigid backing with waterproof scotch tape we can either wait for it to dry or we can begin to apply colors immediately. When painting in watercolor on a wet surface, the paint will begin to spread, one color into another. This can be controlled with a dry sponge or blotting paper.

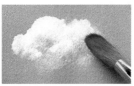

A cloud produced by dry-brushing the color from the wet paper.

MORE INFORMATION

Different techniques for painting trees **p. 12**

Types of brushstrokes: applying paint **p. 42**

Animals in a landscape **p. 46**

ACRYLICS AND THE LANDSCAPE

Acrylic paint is the most important technical development in contemporary visual art. Acrylic paint is comprised of water and polymerized resin, and is soluble in water and requires no other solvent.

Acrylic paint appears almost identical to oil paint, the difference being that it dries almost immediately. We can therefore paint with a medium that combines the richness of oil combined with the speed of drying of watercolor. It can have either a matte or gloss finish depending on the wishes of the artist.

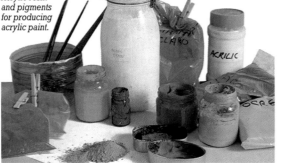

Acrylic resin and pigments for producing acrylic paint.

What Is Acrylic Resin?

Acrylic paint is composed basically of particles of polymerized (synthetic) resin and water; its density depends on the proportion of water added.

It can have a translucent or milky appearance when applied mixed with much water in repeated coats.

The range of colors acrylics offers us is as wide as that of oils.

There are two characteristics that make this medium so versatile. One is the speed with which it dries and the second is its solubility in water.

Acrylic paint can be made at home by simply mixing and stirring resin and pigment. However, for most artists it is advisable to buy it in tubes like oil paints.

A Good Technique for Landscapes

Acrylic paints dry very quickly, maintaining a stable and luminous color. We can achieve the same effects with this medium as we can with oils or watercolors by simply varying the proportion of water.

Being a water-based paint, we can use it on paper as well as canvas. Its resinous base allows us to paint on any nongreasy surface. These properties mean that we can use acrylics for almost any kind of landscape.

A painting can be quickly roughed-out with acrylics and then continued in oil, after the acrylic has dried.

Large surfaces such as the sky, mountains, and backgrounds may be quickly painted with wide brushes, and may be refined and blended while the paint is drying.

Acrylic paint in tubes.

Acrylic allows you to paint light over dark, as it is totally opaque. A tree can be painted by first brushing-in that part of the background containing the darkest colors.

Watercolors and the Landscape
Acrylics and the Landscape
Oils and the Landscape

19

Olive green is used as a foundation for brighter colors.

Stressing the relationship of colors, a chromatism similar to that of oils can be achieved.

Disadvantages

Acrylic paint's great advantage sometimes becomes a disadvantage, as the weather has a great effect on drying time. When painting outdoors on a hot day, the paint will dry very rapidly, even while still on the palette. To prevent this, only the amount of paint to be applied should be placed on the palette.

The brushes must also be carefully cared for, because if they are allowed to dry out, they will become useless. Therefore, frequent immersion in water is necessary.

Textured Work

As with oil, impasto painting (application of thick paint) is also possible with acrylic. The flexible nature of the medium allows the creation of heavy textures with a palette knife without future danger of cracking.

After laying out the forms in a landscape with thin paint, the impasto technique can be applied with either palette knife or brush often creating textures that correspond to such elements in actual subjects such as rocks and trees.

The Palette and Color

The range of colors in acrylic painting is as wide as that of oils, although certain tones may fade slightly when dry, a factor to consider when placing certain colors in relation to others. This drawback

The application of paint can be liquid and transparent. Acrylic paint dries very quickly, allowing successive layers of color to be immediately applied.

Color blending is possible while the paint is still fresh.

can be due to the quality of the resin used in the paint and the purity of the pigment.

Generally speaking, darkening of colors as they dry occurs more often in pure colors, such as cobalts. This is why it is advisable to use top quality brands to ensure

Applying the Medium to the Theme

Acrylic paints make it possible to complete a picture very rapidly. It is ideal for painting landscapes using the *alla prima* technique.

The detailed work can be done next, unhurriedly but with sufficient speed so as to allow for color blending while the paint is still drying.

MORE INFORMATION

Different techniques for painting trees **p. 12**

Out-of-the-tube acrylic paint can be worked in much the same way as oil.

the stability of the colors.

Mixing on the palette is carried out in much the same way as in oil paint, both for the chromatic evaluation and the direct application of the color, always bearing in mind that slight variations in tone that may arise when dry.

OILS AND THE LANDSCAPE

The "queen of techniques," oils, has come down to us from the time it was introduced into Italy from Flanders during the Renaissance.

It is a unique technique, dries slowly, and remains stable over time. It offers an almost infinite number of textures and hues, which explains why most painters use it for landscape painting. One of the main features of this medium is the opportunity to make changes during a long drying time. For this reason, oil is the perfect medium for those who approach their work with uncertainty.

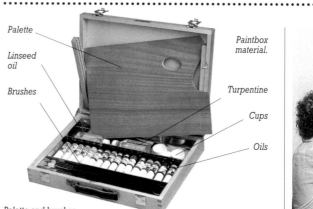

Palette

Linseed oil

Brushes

Paintbox material.

Turpentine

Cups

Oils

Palette and brushes.

differentiate planes, or detailed work such as flowers and other delicate elements in the landscape.

Maulsticks allow steady brushstrokes.

Palette knives and maulstick.

A Traditional Technique

Oil is the earliest known pictorial technique after tempera and fresco, and it is believed that one of its first uses was in landscape painting.

Throughout its history, oil paint has served every need of the visual artist. This is particularly true for the landscape painter.

Oil paint is comprised of oil (walnut or linseed) and turpentine in equal proportion, plus pigment. Pure turpentine is also used as a solvent.

Oil can produce gentle gradations of luminous colors for painting skies; abrupt tonal separations on the horizon to

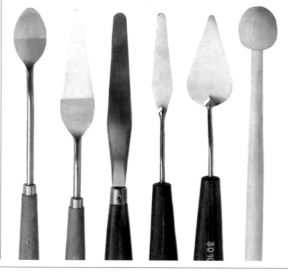

Acrylics and the Landscape
Oils and the Landscape
Alternating Techniques

21

Chromatic Potential

Oil is an unrivaled technique. It is the pictorial medium that best represents the most subtle tonal variations of a single color. If we observe a tree we can see the numerous colors that envelop it, and oil can reproduce these if the artist's perception is able to capture them.

Using just three colors (yellow, blue, and red) plus white we can paint any color in nature. If a certain chromatic approach is chosen (cool, warm,

With three colors plus white, any chromatic range can be developed.

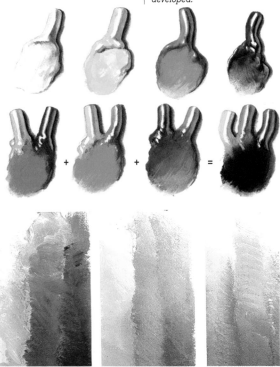

or neutral), the resulting tonal variations will belong to a harmonic set of colors.

The primary colors are mixed to obtain the secondaries (yellow and blue produce green, yellow and red produce orange, blue and red produce violet).

Surfaces for Oil

You can paint with oil on virtually any kind of surface, provided it has been primed with a sealer (glue, varnish, or plastic). For painting landscapes outdoors, it is always advisable to have a rigid surface, such as cardboard, canvas-covered cardboard, plywood, or masonite, although we should always consider using stretched canvas, especially if small or medium in size.

Virtues of Oil

Being a dense, luminous, and opaque medium, oil makes it possible to make corrections during the course of the painting and even after it is finished. This enables the artist to add or remove elements from the landscape, or change colors and forms.

Landscape painting in oil often requires correcting. The position of a tree may not be quite right, bushes may conceal part of a plane and need removing, and so on.

Oil is the ideal medium for beginners, as changes can be made as often as necessary.

For the landscape painter, the work must be easy to carry. This handle separates the paintings in order to carry them.

Religious Scenes

The Church was the patron of art until almost the eighteenth century. Artists often introduced landscapes, or even nudes, into the religious subject.
This oil painting, created by Carpaccio in 1520, is a sample of the technical possibilities offered by this medium. The chromatic gradations and plastic potential of oils let us achieve unique representations of nature.

MORE INFORMATION
Alternating techniques **p. 22**
The fast sketch: outdoor equipment
p. 24

ALTERNATING TECHNIQUES

There is an important caution in painting: "Paint fat over lean." Following this rule there
is no limit to the creative possibilities in interpreting a landscape.
Experimenting with various techniques will often result in surprising effects that will
enhance your painting.

Alternating Acrylic and Oil

When acrylic paint dries, its surface is flat, i.e., non-oily, and therefore can accommodate oil paint.

If, in a landscape, the first application of paint is not given an opportunity to dry, it will tend to mix with subsequent coats of paint, giving an unwanted muddy look to the colors. This problem can be overcome by doing the initial work, and even some of the more advanced work, in acrylic paint. The painting will dry much faster and can then be completed using oil colors.

Although doing the initial work in acrylic is similar to working in oils, acrylic offers a number of creative opportunities while in the drying stages, such as smearing and the use of *frottage*.

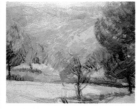

Acrylic paint dries quickly.

Acrylic paint can be used through all stages of the work.

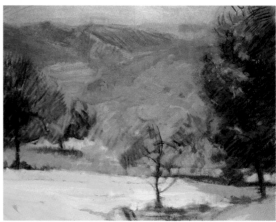

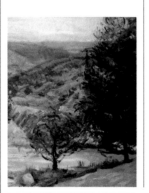

The finish and final details of the painting can be undertaken once the acrylic base has dried.

Quick Beginning and Slow Completion

Working methods that involve the use of different techniques require a conscientious and thoughtful approach. The beginning stages of painting, involving composition and color scheme, are usually done rapidly. However, the artist must be careful not to involve too much detail, in that simplicity is the key to pictorial power.

Working in the Studio

Landscape painting should not be confined to working outdoors. Studio work can be just as rewarding as when working in the countryside, in that many experimental processes cannot be accomplished outdoors.

A photograph can be used in the studio for preliminary work, sketching may be carried out, and, of course, whatever comes from the imagination. There are infinite possibilities, from enlarging with a photocopier to work in collage, plus experimenting with all sorts of techniques.

Beginning with a single color sketch of a landscape, variations on the techniques and sizes can be worked on, methods that are difficult to attempt outdoors. In addition, the indoor studio provides one's store of art materials, running water, and light at night.

Photographs and graphic materials. Useful for working in the studio.

Combining Techniques

Many techniques can be used when starting with the subject of a landscape. If you are going to create a collage, a rigid support such as cardboard or wood is advisable. Also necessary are glue (white carpenter's glue if pos-

Different materials and tools for creating a collage.

sible), scissors, a knife, different kinds of paper, plus photographs, etc.

Designing and drawing a landscape is above all a work of synthesis, the pieces of paper being arranged on top of the support. They should not be glued down until you are sure about the composition.

The planes in the distance are the first to be applied, using glue and a brush. The remaining planes are then superimposed.

Once the collage is in place, you may want to add paint to lend unity to the work or to highlight certain forms.

Cutouts from magazines and colored paper are useful for producing a collage.

An initial layout must always be used.

You can photocopy your own work and apply it as a variation.

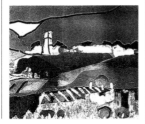

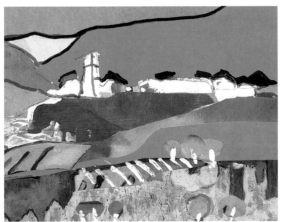

MORE INFORMATION

Acrylics and the landscape **p. 18**

THE FAST SKETCH: OUTDOOR EQUIPMENT

One of the most common ways of learning how to paint landscapes is to go out and paint spontaneous color sketches of the subject on the site.

The sketch is an exercise in capturing the subject you have in front of you, a task that requires constant practice in order to obtain a variety of interesting results.

Drawing, scale, composition, and color are but a few of the factors that must be considered when doing a sketch.

Since artists require very little equipment for sketching, they can go practically anywhere to sketch.

The Easel

Outdoor painting easels must be light, sturdy, and easy to use. An outing in the country can be torturous if you go loaded down with equipment that is more of a nuisance than an aid. Therefore it is essential to choose a suitable easel. The paper pad should be of the type that can be used both for drawing and for watercolor painting. A piece of masonite or plywood will do as a support. A fold-up metallic easel is most versatile for outdoor painting as it is small and light.

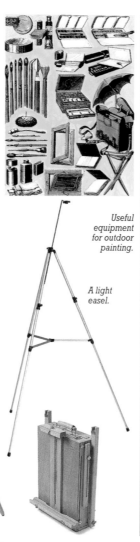

Useful equipment for outdoor painting.

A light easel.

A box-easel.

Materials: Watercolors, Ink, Oils, and Pastels

One doesn't require much equipment for painting fast sketches. Take along only what you really need.

• For watercolor it is essential to have paper to paint on; there is a wide variety to choose from. Fine and rough surface paper can be bought in sheets or pads.

Fine surface paper brings out the transparency but does not allow too much color saturation. Watercolor brushes are made of a variety of delicate fine hairs, the best of which are made of sable. The most convenient way of protecting your brushes during transportation is to roll them

Pads of drawing paper and watercolor paper.

Different types of hand-made paper.

A complete watercolor kit.

up in cardboard. Watercolor paints come in a variety of different packaging. There are several specially designed paint boxes for painting outdoor sketches that include a water container.

• Ink. If you want to paint your sketches in ink, you can do so on watercolor paper, although it is better to work on a more glossy surface. India ink is sold in bottles and, since ink is a water medium, you will require a container of some sort for diluting it and for cleaning the brushes. Ink can be with applied with a brush or a pen nib. Reed pens are especially good for obtaining large, languid strokes. Paper towels, cotton cloths, and sponges are

India ink is available in different containers.

Various useful accessories for watercolor and ink.

essential when working with watercolor or ink.

• Pastels. Dry techniques, such as drawing and pastel painting require little equipment. Drawing paper, a piece of cardboard to use as support, pencils or pastels, a hard and a soft eraser, and a small knife should suffice.

• Oils. Make up your mind right from the start. Are you walking to the painting site and must therefore carry as basic a kit as possible, or are you driving and can afford a full box-easel? Regardless, make a list and check every item before leaving.

Drawing Pads and Canvas

The artist may choose from a wide variety of drawing pads and sheets of different

Different accessories required in oil painting.

qualities. Sizes range from large to pocket-sized versions, the latter being ideal for taking on excursions.

With regards to working surfaces, you should choose sizes that are easy to carry around. Some brands of canvas board fit into standard-size paint boxes.

The Camera

The camera is extremely useful for the landscape painter, who can use it to take photographs of the subject and then use the photos in conjunc-

The Impressionist Landscape

Monet, together with his Impressionist colleagues, painted most of his pictures out-of-doors, striving to capture the colors and light of the moment.
Until Impressionism, many painters worked solely in the studio. This new working habit brought about new, lighter easels.

tion with painted notes for future paintings. So always remember to take a few pictures of the subject used in your sketches.

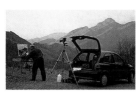

Painting outdoors is always a thrilling experience, especially if you are well-equipped.

MORE INFORMATION
Watercolors and the landscape **p. 16**
Acrylics and the landscape **p. 18**
Oils and the landscape **p. 20**
Alternating techniques **p. 22**

Reed pens for use with ink.

WORKING IN THE STUDIO

The landscape need not be painted solely in the countryside. Artists can also work in the studio with the notes and photographs they have taken of the subject. Furthermore, they can revert to photographs in magazines and even postcards.
In addition to the necessity for good organization both in terms of materials and ideas, the studio must meet a number of basic requirements.

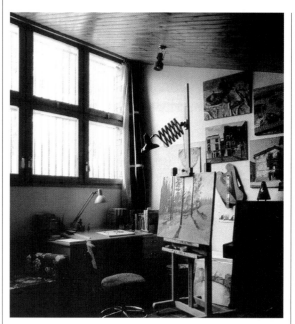

Good lighting is one of the most essential requisites for working in the studio.

Illumination

Lighting is one of the most important elements in any studio. The painter's workplace requires at least three main light sources.

• A window that lets in daylight to illuminate the working surface and the subject, thus allowing the artist to compare the two to ensure that the chromaticism is correct.

• An overhead lamp, used to remove unwanted shadows.

• A goose-necked lamp attached to the easel for lighting the subject.

The Use of Photographs and Sketches

The landscape artist usually has a collection of books and photographs that can be referred to when searching for new ideas. The photographs and notes taken on outings can provide one with interesting starting points.

It is useful to position the subject near the painting, preferably on the same plane and with a uniform lighting source.

A photograph provides only a partial view of the subject, for which reason it is advisable that you take several snapshots of the subject from different angles.

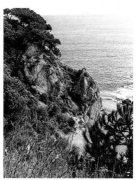

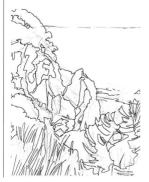

Photographs and notes are of invaluable aid for the artist.

Basic Equipment and Furniture

You will need some basic furniture in order to make your work in the studio comfortable and pleasant. Your easel has to be sturdy and stable. A work surface can be improvised with two saw horses and a firm sheet of plywood for drawing and examining photographs. The lighting should be strong and white, preferably 100-W daylight bulbs or fluorescent fixtures.

The painting equipment and accessories must be kept tidy and within easy reach.

Finally, you will need several containers to keep your brushes upright; also containers or shelves to store pencils, pastels, paint, and other tools.

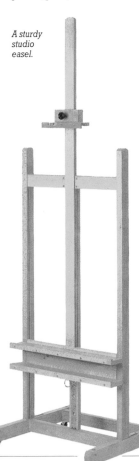

A sturdy studio easel.

Working in the Studio

You don't need a large studio for painting. A well-organized small and tidy space is adequate.

Light is one of the most important factors in a painter's studio. The best type of lighting is from a source opposite from the artist's working hand.

The correct distribution of elements in a studio.

Other items might include a collection of art books, a music system, stools and chairs, a hot plate for coffee, etc.

Use of Outdoor Equipment

Field sketches are used to capture impressions from nature and put them to use in developing a future painting. Draw as many sketches and take as many photographs as you can.

When it comes to painting a subject in the studio, the artist should have as much graphic material as possible available.

An improvised work surface.

Cleaning Materials

Your materials should be kept clean and tidy so they are easy to locate at any given moment. If you are working in different media, it is useful to keep the materials relating to each separately.

Each medium requires a different type of care. Water-based mediums like watercolor, tempera, or acrylics can be cleaned under the tap; oil is cleaned with turpentine and then soap; dry mediums, like pastels, are kept clean by rubbing a dirty cloth over their points.

Different water containers, ideal for cleaning brushes and working with watercolor.

A cloth is essential for painting in pastel.

MORE INFORMATION

Different techniques for painting trees **p. 12**

Alternating techniques **p. 22**

The fast sketch: outdoor equipment **p. 24**

The quick sketch in lead pencil **p. 34**

TECHNIQUE AND PRACTICE

LANDSCAPE COMPOSITION

Composition is essential for painting a landscape. To compose a picture is to arrange the elements within a determined space, a task that requires a careful study of the subject and a correctly proportioned representation of the elements on the canvas. There are a number of rules of composition the artist should follow when painting a landscape. One refers to the golden section, a mathematical formula also used for structuring elements in architecture; another is the balancing of the masses, which helps you to correctly arrange the different "weights" within the picture.

The Golden Section

Curiously, this ancient theory for arranging the spaces in a painting has been employed throughout the history of painting. The search for a balance of masses led the Roman architect Vitruvius, during the first century A.D., to the ideal division of space in a picture. This rule was applied to most of the paintings of the Renaissance and continues to be employed to this day. The Golden Section can be defined thus: for a space to be divided into equal parts and to be agreeable and esthetic between the smallest and largest parts, there must be the same relationship as between the larger part and the whole. To find this ideal proportion, you have to multiply the width and length of the canvas by the factor 0.618, which will give you the division of the Golden Section, that is the point in the picture that receives the most attention.

Application of the Golden Section rule.

Linear development of the Golden Section in a rectangle.

The Color Masses in a Composition

A logical distribution of space has to be balanced by the color masses. Imagine for a moment that colors possess physical weight, and that this weight would have to be correctly distributed among the composition's elements, in a way that the physical space they take up complies with the law of gravity. Therefore, the darkest colors would be seen as being denser and heavier than the lighter ones. Likewise, the dark colors would undergo a devaluation in tone, due to the effects of distance in perspective.

Wou Li (1632–1718), Sailing at the Foot of a Buddhist Temple (Palace Museum, Taiwan).

The Point of View in the Oriental Composition

This landscape was composed using an elevated viewpoint, a characteristic of traditional Chinese painting. This type of composition divides the landscape into two masses of space that are separated by a single line. In Chinese painting, the "ascending" composition enables depth to be achieved without the need to resort to perspective. This effect is obtained by using successive planes.

The Balancing of the Masses

Balance is not only achieved by the equilibrium of masses, but also, in the case of a monochrome picture, by values. Tonal values also have a decisive role to play in balancing the weights of a landscape.

A larger mass of color can be compensated by another darker and smaller one on the opposite side of the picture. The landscape can be said to be balanced when the proportions between the lines and masses of color are harmonized together.

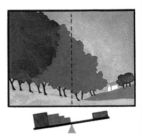

The weight is not correctly distributed.

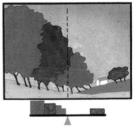

The weight of value masses balances the composition.

Symmetry destroys movement and force in the composition.

Asymmetry contributes to the dynamic values of a landscape.

Asymmetry in the Composition

In the landscape composition there are several factors to take into account when choosing a viewpoint from which to paint. Even in the least realistic landscape there is a tendency to look for asymmetry. This enables us to locate the other compositional values, such as the balance of the masses and the painting's center of interest.

Asymmetry in a composition has a significant influence on the dynamism of the work, which is the reason why elements skillfully distributed will acquire more interest than one in which the elements are distributed symmetrically. The subject of perspective can also be decisive in an asymmetrical landscape composition.

Types of Composition

Independently of the subject, we can choose whatever type of composition we wish to use. Every composition is different with respect to the distribution of the planes and the artist's viewpoint. Diagonal, circular, triangular . . . are just a few schemes that the artist can use as a guide.

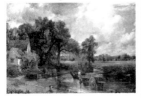

Diagonal composition.

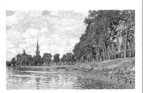

Curved composition.

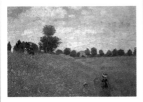

Linear plane composition.

Balance in a Twentieth-Century Landscape

A correct distribution of masses is not incompatible with freedom of expression. In this picture by J. Miró (*La Masía*, 1918–1922. Ernest Hemingway Collection, New York), there is no perspective whatsoever. The composition has become the center of interest. The elements have been reduced to flat jigsaw puzzle-type shapes.

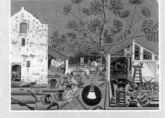

ADAPTABILITY

One of the compositional aspects that most affects the result of the painting is the adaptability, the way in which the composition is framed within the dimensions of the canvas. Having chosen a viewpoint, we have to decide what part of it we wish to include. The best way to obtain adaptability is to lay out the most important lines of the landscape, thus establishing the exact center of attention. This involves dividing the canvas into different areas in a relationship with the perspective as well as all the other compositional elements.

The Division of Space

The landscape's most important lines have to be located so that the space is structured in a balanced way, which then allows the artist to distribute the masses in a proportional manner.

Of course, the first division of space can be rectified when you apply the color, adding or deleting the weights of the areas we have established in the composition.

The structure of a landscape is its framework and the lines that explain the different spaces establish the planes in the picture.

The Planes in a Picture

A landscape is a three-dimensional theme that we have to represent on a two-dimensional surface. Therefore, we

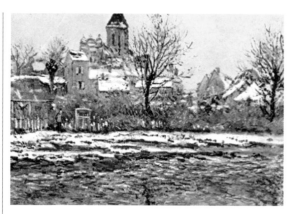

An example of the sensation of depth obtained by means of successive planes (Monet, Effect of Snow).

have to reduce the subject to a series of successive planes in order to express distance and proximity; you will see how the foreground automatically separates itself from the more distance planes. This is one method for establishing the third dimension in painting.

The three-dimensional effect is resolved, therefore, by means of different planes, which, emphasized by the lines of perspective, provide us with depth.

Adaptability and Perspective

The adaptability of the subject establishes the composition and the perspective provides it with depth. Perspective can be built up in two ways: making use of successive planes that establish various points of distance, or establishing a point of conflu-

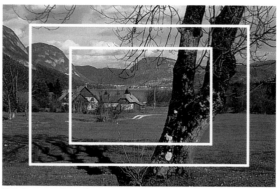

Note how a single landscape can be changed according to the choice of planes.

ence of lines around which the landscape can be constructed.

If we choose a distant, elevated point of view, the lines of perspective will provide us with a wider view, while if we choose a convergence of lines, we obtain a narrower depth of field.

Adaptability and Composition

There are various useful devices for ensuring good adaptability. One of them consists of

attaching two right-angle strips of black cardboard together (see photo), which, when positioned in front of the subject, can be adjusted to find the most appropriate format for the composition you are about to paint. A multitude of different possibilities can be obtained by widening and narrowing the field of view and moving closer or farther away from the subject.

The "Weight" of Color

Once we have chosen the composition by framing the

The "weight" of color greatly influences the composition.

theme, we should turn our attention to the proper arrangement of the masses.

In principle, the first lines that mark out the spaces are destined to enclose the colored masses, which are established as the work progresses.

Bearing in mind that the colors and tones possess their own "weight," it is important to search for a balance from the very start, giving priority (if it is desired) to the compositional values rather than those seen in reality.

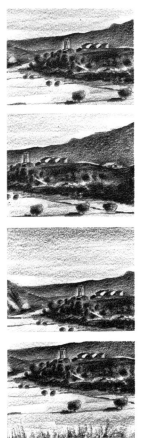

Different points of view affect the composition and depth of field.

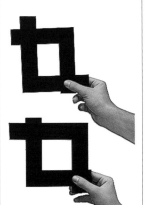

Different compositions can be obtained by framing the subject using two pieces of cardboard.

Adaptability and Depth

In this work by Millet (*El Angelus*, 1857–1859), we can see an excellent example of framing in which the composition balances the whole. The heightened depth is achieved

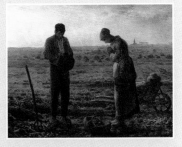

by the excellent placement of the painting's elements. The point of view coincides with the horizon line, creating between it and the viewer an accentuated perspective due to the depth of field and the elements, which create other planes of distance among themselves. This effect is further heightened by the blurred forms of the most distant elements.

MORE INFORMATION
Composition in the landscape **p. 28**
The planes in a painting **p. 32**

MIDDLE GROUND, GENERAL PLANE (DIFFERENCES BETWEEN PLANES)

We may interpret a landscape from different viewpoints. If we focus our attention on the features nearest to us, we can interpret the plane in the foreground. If, on the other hand, we are interested in the different planes between the foreground and the background, we acquire a space in depth that contributes various other planes.

Superimposing Planes

By establishing the different planes in a subject, it is possible to obtain an effect of depth in a painting. These points in space between the observer and the landscape indicate the distance between them. If we begin with the foreground (the object closest to us), we will have established the first area of separation in relationship to the background.

The most basic rules of perspective, together with our intuition, allow us to see that a more distant object decreases in size in relation to closer objects.

A landscape is a series of interrelated planes composed of various objects. Objects located in the foreground are key

The different planes create depth.

to distance because of the diminishing size of objects as they occur on planes receding into the background.

Planes and Composition

The composition provides the painting with a balance of structure and weight within a picture plane. A picture plane can be understood in two ways: it can be perceived as a whole, that is, as a flat surface occupied by various colors, or as a composite of different elements in a picture according to their location and weight within the composition.

The Location of Planes in a Painting

The location of different planes influences the composition in such a way that the essential structure of the picture in terms of balance and the distribution of weights must now be related to the planes themselves.

• *Foreground:* the first reference point of a landscape and our location in front of it.

• *Intermediate plane:* shows the elements in depth and

A distant plane tends to scatter the subjects.

establishes a link between the foreground and the background.

• *Background:* the place where the horizon line is situated according to our viewpoint.

A closer plane increases interest and lets us play with the composition.

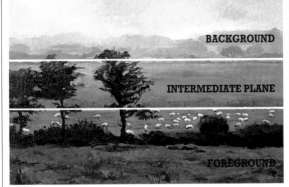

BACKGROUND

INTERMEDIATE PLANE

FOREGROUND

Color helps to separate the different planes.

The Viewpoint

The viewpoint establishes our height with respect to the landscape. An elevated point of view provides us with a specific view of the landscape, a more expansive one in this case, while a landscape seen from a point of view below the horizon line increases the depth, this being the most common situation. The height of the horizon line establishes the depth of the picture.

Chromaticism and Distance

The different planes are not only distinguished by their spatial location and the rules of perspective; chromaticism also plays an important role in locating the planes of a picture.

The colors fade as the planes recede into the background. The farther away they are, the more uniform they appear thanks to the atmosphere's filtering effect. This effect makes the distant colors of the landscape take on a bluish hue.

Therefore, the foreground contains more warm tones, whereas cooler tones become predominant as the planes recede into the distance.

The Use of White in a Landscape

The palette is an essential tool in obtaining suitable colors. A landscape contains a wide variety of hues that, if we do not take the trouble to study them, can escape our attention.

There is no such thing as a single green in the countryside or a specific earth color. The climate, the shadows, and the presence of other nearby colors alter the hues of everything.

The greatest danger the landscape painter has is to fall into what is commonly known in the trade as the "gray trap." In other words, the excessive use of white mixed with other colors, which can reduce their brightness dramatically.

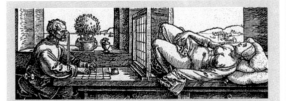

The Use of the Grid

This fifteenth-century engraving shows a drawing technique employed during the Renaissance. This system eases the job of working out the proportions of the different elements in the picture, because if we look through the grid with only one eye, the third dimension is reduced to just one plane.

MORE INFORMATION

Composition in the landscape **p. 28**
The planes in a painting **p. 32**

THE QUICK SKETCH IN LEAD PENCIL

Drawing is the medium that most closely reflects the exact reality of the subject. It is drawing that enables us to see the subject in its precise relationship to the picture. By emphasizing tones and indicating volumes with simple lines, we can give the illusion of a third dimension. The quick sketch, therefore, simplifies the assessment of the subject. It is the intermediate step between the artist's understanding of the subject and the painting to come. Color values of a subject are implied through the various shades of the pencil.

The Motif

It is essential to be absolutely clear about what your idea is before you begin sketching it.

The subject of your sketch will depend on what you want to focus on; a landscape can be interesting for its location or its composition. In any case, it is best to do various drawings so as to have a choice of the best one.

The Evaluation of the Underpainting

All the elements of the subject can be reduced to basic

The best way to see the distribution of masses in your composition in synthesis is to look at it through squinted eyes.

geometric shapes and scales of gray.

It requires much practice and perseverance to interpret a landscape. The elements that form the masses of the landscape fade as they recede into the distance; the farthest planes take on a grayish blue tone, an effect that can be obtained by means of a tonal scale of grays. This tonal scale will depend on the hardness of the pencil you use.

The Size of the Paper

A fast sketch drawn from nature can be done on practically any type of paper. Given the fact that you often come across a landscape by chance, you should always carry pencil and paper wherever you go.

On the other hand, an inexpensive cardboard portfolio can be used both as a support and to keep your drawings and notes in.

This is a drawing of a theme that is then turned into a definitive painting.

This is a painting based on the sketch shown above.

Gradation of grays in pencils according to their different degrees of hardness.

8B	
7B	
6B	
5B	
4B	
3B	
2B	
B	
HB	
F	
H	
2H	
3H	
4H	
5H	
6H	
7H	
8H	
9H	

Different types and brands of paper.

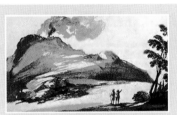

The Perfect Rendering of a Landscape

To understand correctly a landscape you should understand the gradation of grays. Watercolor as well as charcoal and pencil

Guercino, Landscape with Volcano
British Museum, London.

sketching are appropriate mediums for tonal search and evaluation. In this painting we can appreciate the artist's skill and knowledge of technique by the fact that a few brushstrokes have managed to express perfectly the shape of the subject and the play of lights and shadows. The insertion of small human figures in the foreground leads to a better understanding of distances and proportions.

Drawing sketches from nature.

A drawing case is useful for carrying your accessories, including paper and such things as watercolors, charcoal, etc.

Stumping and Expression

The expression of your sketch will depend on the spontaneity of the stroke. A drawing will appear spontaneous and alive if it is given the right emphasis, that is, pencilwork that involves using not only your hand but also your wrist and forearm.

This form of expression is fundamental in the creation of any exciting drawing, since it conveys your whole strength and character.

Another technique used for developing details consists of stumping and blending with your finger or, in the case the detail is too small, with a paper stump. Stumping is excellent for combining lines with gray transitions.

Taking Advantage of the Light

Sketching from nature can be a delightful experience under optimal lighting conditions.

However, sometimes the light reflected off the painting surface can dazzle you and

Each artist should have a personalized way of working.

limit your vision; in other circumstances your shadow can interfere with the work on the paper. In order to prevent this from happening make sure you are sitting in the shade or under a parasol.

Fast and Productive Work

Make a habit of drawing sketches of landscapes. Only those artists who have mastered the art of drawing and composition can obtain really satisfying results.

Sketches must be executed with speed in order to capture the most important aspects in few lines. This is only achieved through continuous practice.

It is always necessry to control the drawing.

A good sketch must analyze the subject in perfect synthesis for a future painting.

MORE INFORMATION

Different techniques for painting trees **p. 12**

Animals in a landscape **p. 46**

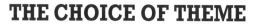

THE CHOICE OF THEME

Each landscape has its own particular chromatic character that makes it unique in relation to all others. The painter must use the cool, warm, and neutral chromatic ranges to enhance the theme. A snow-covered landscape would favor a cool range of colors, while the scene of a wheatfield in summer would favor a warm palette.

The Theme and Color

The theme you choose will always have a predominating color tendency. All objects absorb all the colors in the spectrum except one, the object's own color, which is reflected back.

But it is not only the object's actual color that influences its appearance. The atmosphere's filtering effect is also a factor and the painter must bear this in mind when selecting a chromatic range to interpret it.

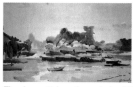

The chromaticism of a work should have a direct relationship with the theme being painted.

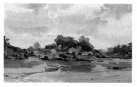

Atmosphere and color define a landscape by themselves.

From Foliage to Scrubland

There are as many types of landscapes as there are ways of interpreting them. Even a single subject can provide the artist with an almost limitless number of compositional ideas and color themes. In landscapes depicting forests or arid lands the horizon becomes all important. Cool colors predominate in forested landscapes while warmer colors are dominant in an arid climate.

The chromatic range also depends on the season of the year. A mountain landscape in winter, for instance, does not have the same chromatic tones as in summer.

From Blue to Yellow. Color Synthesis

The palette chosen by the artist will play a decisive role

The pictorial treatment and chromatic range must be harmonized with the theme of the painting.

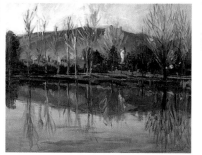

Unreal Color

Until the advent of Impressionism, painters only occasionally ventured out into the countryside to paint. The landscapes they painted in the studio would take on an artificial chromaticism. The artists of the time often used only one color range when the landscape was only intended as a background for a portrait.

in the final result of the picture. Warm color ranges can also be used in the execution of a landscape with a cool tendency.

Color synthesis enables us to understand the landscape according to its tonal evaluation. A good exercise is to draw a fast sketch to establish the subject's tonal values.

The cool range of colors, comprising green and blue, can be perfectly combined with warm earth colors and reds, which will then act as factors that emphasize the chromaticism. That is to say, distance in a landscape is painted in an atmospheric blue.

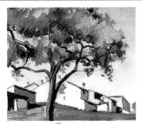

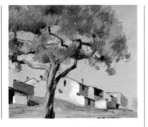

violet. The range of neutral colors is obtained by applying two complementary colors in unequal amounts adjacent to one another.

Color synthesis helps the artist to understand the landscape through tonal evaluation.

Evaluating Earth Colors

It is up to you whether or not to use earth colors. If you do use them, they will play an important role in your landscape.

Earth colors are not all warm; some greens are ideal for mixing with browns and thus becoming particularly appropriate for an expanded palette.

Earth colors are pigments of mineral origin and are obtained by grinding different soils together. They comprise a range of yellow ochre, raw sienna, burnt sienna raw umber, and burnt umber. The character of these colors can be enhanced by adding green. But it is important to bear in mind that green tones can muddy colors, occasionally destroying the desired chromaticism.

How to Choose a Palette

Before you paint your landscape, you must decide on a predominating color.

The artist normally starts with the most basic colors, from which he or she can develop a palette. The range of warm colors consists of yellow, orange, and red. Cool colors are green, blue, and

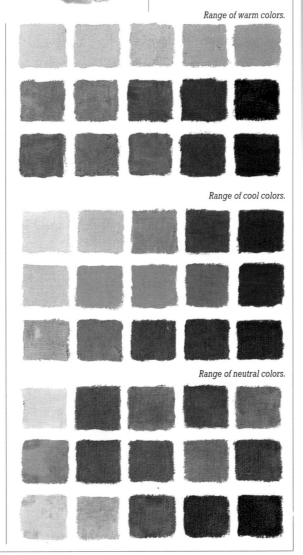

Range of warm colors.

Range of cool colors.

Range of neutral colors.

THE HORIZON LINE AND THE POINT OF VIEW

The landscape can be understood in as many ways as it can be represented. Sometimes this theme can include a sizable area; on other occasions, the desired portion of landscape is so small that it can barely include three or four trees and a tiny brook.

When artists set out to paint a landscape, they must first analyze the elements they wish to include in it to see how they relate to one another in terms of color and distance. A scheme for a landscape locates the different elements and planes of the subject through the use of various types of perspective.

The Background Conditioned by the Viewpoint

When viewing a landscape, the spectator is always situated at a certain height. The height with respect to the plane establishes both the distance and the scale of elements. The spectator has a specific space before him, which will vary according to whether his viewpoint is higher or lower. That is to say, if a piece of land containing two trees is seen from a low viewpoint, they will appear almost joined together on the plane, leaving the farthest tree reduced in size because of the effect of distance; if, on the otherhand, it is seen from a higher viewpoint, the farthest tree will not look as small, but the distance between will seem greater.

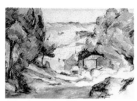

A landscape by Cézanne painted from eye level.

A typical viewpoint used for painting a landscape.

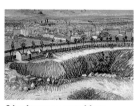

A landscape executed from an elevated viewpoint enables the artist to include a large part of the scene.

The High Horizon Line

The viewpoint is located on the horizon line directly in front of the observer. The vanishing points are where a series of imaginary lines converge, and in the process determine the location and size of each object in the composition.

From an elevated viewpoint vanishing points can be established that meet on the horizon line, creating a wider view of the landscape.

The relationship that exists between the observer's viewpoint and the horizon line indicates the space represented in the landscape, in which an elevated viewpoint provides a more extensive view of the landscape.

Low viewpoint. The horizon line loses depth.

The Low Horizon Line. The Relationship with the Sky

In a composition seen from an elevated viewpoint, a high horizon line displays a large proportion of the landscape, whereas on the other hand, the lower the horizon line and the less depth the landscape has, the more important the elements in the foreground and middle ground become.

If a landscape is painted with a low horizon line and the elements in the foreground are not made more prominent, the area of the sky will become increased, depending of course on the picture's format. The sky is, of course, a very important element in the painting both in terms of the theme and the composition.

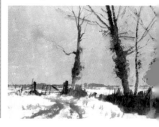

In a landscape painted from a low viewpoint, there is less depth and the elements in the foreground and middle ground acquire more importance.

The Choice of Theme 39
The Horizon Line and the Point of View
Chromatic Evaluation and the Atmosphere

Perspective

A landscape is a three-dimensional subject reproduced on a flat plane. For this reason, the artist has to use rules of perspective to represent the illusion of a three-dimensional scene on a flat surface.

The representation in the first illustration (1) shows objects on a plane, without perspective; the second illustration (2) shows the same objects superimposed, an effect that creates the illusion of depth. But if we draw a scheme of the real perspective (3) and add colors and shadows to it (4), the illusion of volume is increased.

There are many ways of creating a third dimension in landscapes: by means of the superimposition of planes, by the use of perspective, or

Gradual perspective.

through the use of color to describe depth in the picture.

Vanishing Lines

In order to paint a landscape, it is important to know how to correctly situate the different elements of the picture. By applying the basic rules of perspective, you can draw the objects in accordance to their distance from the observer.

If we establish a vanishing point (VP) on the horizon and draw a line (HL), then draw the land line (LL) and mark out several points on that line, and then run lines to those points,

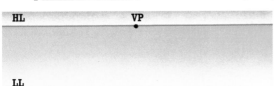

The location on paper of the horizon line (HL), the vanishing point (VP), and the land line (LL).

Draw several equidistant objects on the land line and then their corresponding lines to the vanishing point. These will indicate the size and form of the objects in depth.

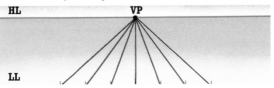

The Renaissance and the Development of Perspective

Until the end of the Gothic Period, perspective was understood as a series of successive planes in which the objects were not reduced in size. The theory and practice of perspective during the Renaissance provided painters with a new way of representing a three-dimensional subject on a two-dimensional surface. This effect of depth left the observers of Renaissance art spellbound.

we will have created vanishing lines, along which the placement and size of all elements in the composition will be determined.

Depth of Field

It is not always necessary to use perspective to create the third dimension in a painting; in fact, despite the usefulness of the rules of perspective, when we paint a picture we often have to use our intuition when laying out a scheme.

The depth of field is a visual effect that is produced when you look at a specific area in a landscape. The center of attention makes the other areas appear less important, more blurred or hazier. This effect can be achieved through color, composition, or simply by studying the subject and then correctly locating the planes of the picture.

MORE INFORMATION

Evaluating planes in pastels **p. 14**
Detail and perspective **p. 54**

CHROMATIC EVALUATION AND THE SURROUNDING ATMOSPHERE

The colors you have chosen to paint your landscape will greatly influence its outcome. Aside from the type of palette used, the artist should take into account that the colors employed in the development of a landscape have weight and value in relationship to the whole. There is no such thing as an exact palette for the general interpretation of a landscape. Even beginning with the most basic palette, the color relationship between the subject and the painting can be made identical.

Color and Realism

A realistic chromaticism is that in which the observer's eyes do not detect any distortion with respect to the logic of light and color.

The atmosphere filters the light and therefore changes the color of the objects it is reflecting. There are several styles of painting that are used to achieve a realistic painting.

• The *valuist* style, in which the painter makes use of local colors and values to bring out volumes. This type of landscape painting requires us to carefully study the shadows of the objects themselves and the shadows that they in turn cast.

• The *colorist* method, in which the artist does not see the shadows as darker tones

A landscape painted in the colorist style.

of the local color, but colors in their own right, frequently of the same value as in the lighter areas.

An example of colorist contrast in a painting.

Colorist Chromaticism

A landscape can be interpreted from a colorist point of view, that is to say, giving a value to each tone generated by the objects, both in the shadows they receive and the ones they cast.

It was the Impressionists who first treated painting from a colorist point of view. For the first time, painters not only concentrated on landscape but employed color for color's sake. The colorist painter does not view shadows as darker than other areas, but as colors themselves; therefore, objects are differentiated from one another by different color planes instead of a differentiation based on the shadows they cast.

Monochromatic Treatment of a Landscape

The painter has to choose a suitable chromatic scale to find an affinity between the color of the palette and that of the subject. Therefore, the landscape can be interpreted as a series of tonal and value differences of a single color.

The best way to understand a landscape as a series of values of a single color is to look at a black and white photograph.

It is important to understand landscape from a monochromatic point of view, because this will allow you to learn how to evaluate colors in synthesis. Economy on the palette helps the artist to understand both color theory and color synthesis.

MORE INFORMATION

Resolving the whole **p. 44**
Reflections on the water **p. 68**

The Horizon Line and the Point of View
Chromatic Evaluation and the Atmosphere
Types of Brushstrokes: Applying Paint

41

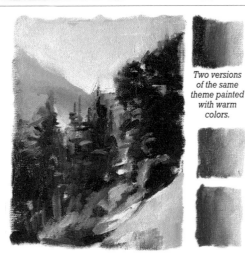

Two versions of the same theme painted with warm colors.

A Landscape with a Warm Tendency

A warm palette can be used to paint a landscape consisting of warm colors, but that does not mean to say that cool colors cannot be included. Cool colors can be used for toning and neutralizing tones that are excessively intense. In fact, you should not exclude any color, no matter which color range it belongs to.

The warm range of colors can be perfectly incorporated with the cool colors. However, you should give priority to the former rather than the latter if you are painting a picture with a warm cast.

The palette of neutral colors can tend toward the cool or warm range depending on the type of picture you are going to paint. This is done by increasing the amount of tones belonging to each range that you want to employ.

A Landscape with a Cool Tendency

In the same way a warm range of colors can be used to paint a landscape domination by cool tones, the cool range of colors can also be used in conjunction with the warm tones. A chromatic excitement in the painting can be created by the interspersing of both ranges of color.

To obtain a neutral quality, it is only necessary to combine warm and cool colors.

The use of violet in combination with khaki not only substitutes for a cool palette, but enhances its chromaticism.

The Harmony of Light

All elements in a landscape acquire a chromatic character depending on their location and the light they receive. Daylight gives the landscape its chromatic tones, which can be synthesized through different harmonic ranges. The artist will have to determine the predominant color in order to begin the picture.

The same theme painted with cool colors.

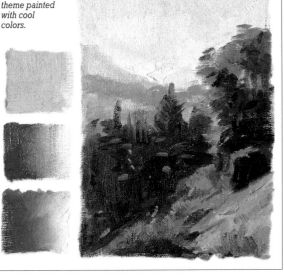

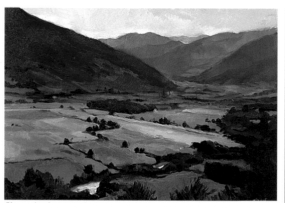

TYPES OF BRUSHSTROKES: APPLYING PAINT

There are as many ways of interpreting a landscape as there are landscapes. But, independently of the technique utilized, you will find that there exists a number of techniques that are useful in executing a landscape. A specific technique may be required to paint the main masses of the composition, while another may be needed to render intricate details.

Alternating between the areas with the brushstroke. The painted area can accommodate more detail by using a smaller size brush.

The Construction of Color Masses

We interpret the different planes of a landscape in a number of ways, but we should first concentrate on distributing the masses and leave the work of defining the details until later on.

Even though the distribution of masses does not affect the perspective of the landscape, it influences the composition by contributing to the structure of the picture as a whole.

The masses of color will define the different planes in the picture; once this has been done, we can begin to develop them to obtain effects such as superimposing planes or creating depth through color.

Wash and Watercolor

Wash or watercolor can be used to carry out a first step of a landscape. A fast, spontaneous work provides an excellent bridge between the landscape and the painting. Wash allows us to see the areas from a monochromatic point of view, thus establishing their tonal variations within the whole while searching out the balance of the composition's tonal weights.

A fast sketch in watercolor enables us to evaluate the painting according to the color, without necessarily having to include too many hues.

Flat Brushstroke

The choice of brush to use in a painting depends on the amount of definition required. If, during the first stage, we

want to cover the entire canvas with masses, it is best to utilize the wide and flat brushes.

When we are concentrating on building up color, the importance of texture is put aside. In certain cases, depending on the medium we are using, a wide brush is better for carrying out this procedure. In the case of watercolor, however, the technique of covering the surface must be done with more care since we are dealing with a totally transparent medium that leaves the underlying applications of color visible through each subsequent step.

In any case, large color masses require a brush that easily covers the area we are working on, moving with flat broad strokes while not attempting to define anything other than the structure of the painting.

A flat brushstroke and the covering power of the color.

Fast Monochrome Painting

By roughing-out the picture it is possible to rapidly resolve the problems of structure and the character of the landscape chosen. Sometimes the application of masses with a single color not only solves the problem of the main volumes but aids us in analyzing the tones of the actual landscape.

Frottage

There are many ways of applying areas of color. Frequently a simple squiggle is enough to suggest a mass of color. Other possibilities include flat strokes and the *frottage* technique. *Frottage* can be applied with a slightly dampened brush or, simply, with a piece of cloth, depending on the accuracy required.

The Drawing and the Painting

The landscape theme can sometimes limit the composition of the picture. Therefore,

The use of different techniques reveals the drawing through the paint.

preliminary drawing is advisable in order to establish the arrangement of elements within the composition.

The drawing models the main form and serves as a guide to where the brushstrokes are to be applied.

It is not easy to separate the drawing from the painting; often it is difficult to see when one starts and the other ends. Of course, painting should

Paint applied using the frottage technique.

never be treated as a type of "painting-by-number" exercise, that is, to simply paint in those areas you have marked out in pencil. It may happen that the line as such is no longer visible, and it is at this point that you begin to draw-paint, modeling shapes and defining the contours.

Alternating Colors with Strokes

The color areas construct the main design of the composition and outline those zones that require separate attention such as the sky, the horizon line, the foliage of the trees, and the greenery of a field. However, these color masses can appear flat. They will have to be worked on once the general roughing-out has been finished. For instance, we can vary the different tones of the trees by adjusting our use of color to the desired result.

The wide brushstroke is alternated with a variety of other strokes: round or flat, narrow or broad, depending on the effect required. In addition, the choice of brush is important in terms of the amount of water or paint it can hold.

MORE INFORMATION

Resolving the whole **p. 44**
Rural buildings, distant planes **p. 56**
Painting foregrounds **p. 94**

RESOLVING THE WHOLE

The first stage of a landscape should include several steps that are fundamental for a successful painting. The artist should not paint a definitive work from the outset. Once the composition and the scale have been established, there is another step between the positioning of the forms and the almost-finished appearance of the landscape. This intermediate phase entails establishing the structure of the composition, in short, setting the basic guidelines for finishing the painting.

Sketch of a landscape in charcoal.

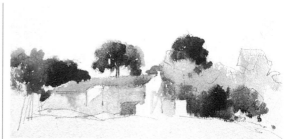

The first stains of watercolor are applied over the sketch to define the main volumes.

From Sketch to Initial Color

It is not easy to sketch a landscape. You have to synthesize the general outlines of shapes and volumes of the future painting. Depending on the medium you are going to use, the sketch can be executed in several ways.

Indicating the elements for a watercolor is done very faintly with a hard pencil, defining the forms in a general way while making everything clearly understood.

In opaque mediums like gouache or oil, the underlying

Pencil sketch for a watercolor landscape.

sketch need not be as subtle as in the watercolor medium.

In the case of oil, the sketch can be executed in charcoal or even paint diluted in turpentine.

Color Approximation

Having drawn the sketch and chosen the color range you are going to work in, it is time to experiment with some of the colors on the palette. Satisfaction may take time, but keep mixing.

In watercolor, the paint is mixed both on the palette and on the picture itself, since its transparency is this medium's

Having drawn the sketch with charcoal, the first applications of oil follow.

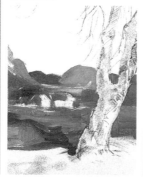

most important characteristic. Take care not to apply the paint too heavily in order to allow for successive layers of paint.

With oil, the color approximation can be carried out gradually on the canvas, with the possibility of being able to correct an area at practically any time.

With oil paint avoid diluting with too much turpentine because the color should remain essentially unchanged during the execution of the painting.

Bearing in mind the difficulty of making changes in watercolor, the first strokes must be exactly what you desire.

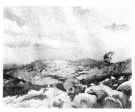

Tonal Adjustment

Once you have finished the underpainting of the picture using one or another medium, the task of gradually adjusting the colors begins. When searching for the definitive colors, the painter should not only compare them with the colors of the subject, but should also pay attention to the chromatic range chosen and the colors already applied to the canvas. It is at this stage that the painter has to use the capacity to synthesize and decide.

Ways of Interrelating Colors

Both in the mixtures carried out on the palette and in the application on the painting, the colors of a chosen chromatic range have such a mutually dependent relationship that a dark color, such as raw umber, appears pale when it is adjacent to a darker color, such as an ultramarine blue.

Colors relate to one another by contrast and by a tonal additive and subtractive synthesis; on the one hand a cool color always appears warm when juxtaposed to an even cooler color, and on the other a dark color always appears paler when it is situated next to an even darker color.

As you can see in the illustration, the cool ochre used to paint the canvas has been turned into a warm color due to the neighboring yellow green.

The Subjective Contribution

When painting a landscape, the artist always changes the subject according to personal criteria. Even when the picture is done from nature, there are many details that need to

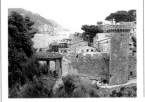

be left out. Likewise, a landscape changes according to the time of day and the season, so imagination and memory are as essential as the brushes and paint themselves in order to be faithful to one's original idea. However, some-

times artists may alter the landscape they are painting, both for compositional and chromatic reasons.

Roughing-out the Canvas

The initial work on the canvas depends to a certain extent on the medium you are using. A watercolor always starts with almost-transparent colors, while in the first layers of an oil painting the paint should be diluted with plenty of turpentine.

A landscape of the Mediterranean coast.

See how color interrelates in this watercolor landscape.

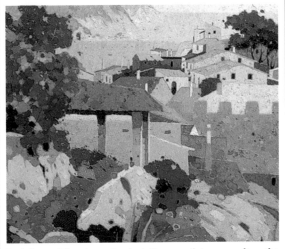

Example of how the artist, using his imagination as a painting tool, has interpreted the landscape shown earlier.

Tonal gradation relationship

Color continuity relationship

Contrast relationship

MORE INFORMATION

Details and spontaneity in painting **p. 10**

Types of brushstrokes: applying paint **p. 42**

Rural landscapes **p. 48**

ANIMALS IN A LANDSCAPE

It is traditional to include animals in a landscape painting to give it a romantic atmosphere or a touch of realism. Just as with all other aspects of a landscape painting, the shapes and movements of animals have to be drawn in harmony with the surroundings. Therefore, if you want to include animals in your landscape, you will have to practice drawing them in their environment.

The Anatomy of an Animal

All shapes can be reduced to basic geometric volumes, a fact that is of enormous help for understanding all objects that surround us.

Bearing in mind these geometric forms, we can represent the different parts of an animal's anatomy on paper or on canvas.

Animals are generally represented in profile or in a three-quarter position, so it is essential to make a thorough anatomical study of the animals you wish to include. The best way to learn how to draw the shape and proportions of a particular animal is to practice sketching it standing still.

Proportioning a Horse

The basic shape of a horse's body seen in profile is a cylinder. While taking care to draw the correct proportions, two cones provide the head and neck; their position might be defined by means of foreshortening.

The legs are situated according to the plane where the animal is located, the inclination in perspective of the earth plane indicates the distance between them.

The animal can be posed in a three-quarter position by varying the position of the cylinder while respecting the cones that form the head and

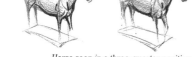

A horse seen in profile.

Horse seen in a three-quarter position.

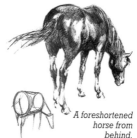

A foreshortened horse from behind.

The legs can also be reduced to tubular lengths; this way, knowing how the joints bend, you can draw an outline of the different positions of the animal's extremities.

neck. According to the parallel perspective of the cylinder, the earth plane indicates the position of the animal's legs.

Animals and Prehistoric Art

Animals provided the first artists with a motif, and were frequently the major subjects in rural and hunting scenes as the plastic arts developed. However, in contemporary landscape art, animals only form part of the composition as elements that contribute an interesting note to a rural landscape.

The Basic Structure of Household and Farm Animals

The relationship of volumes and shadows is easy to do using a soft pencil that allows changes and gradation of the intensity of the shadows and volumes. A schematic drawing of a goose consists of an oval to represent the body. The neck and head consist of an elongated and flexible cone, and the tail, of another small cone. The wings are defined with two simple curves.

The structure of a hen is similar to that of the goose, except the neck, which is a wider stronger cone with another larger one for the tail.

Study of the structure of different household animals.

tures will obviously always begin as geometrical figures. As the picture develops, the painter will decide on the colors, depending on the palette he or she is using.

Contrast by Means of the Underpainting

If in the beginning contrasts are resolved by using a single color, the artist will be able to evaluate the anatomical shapes. Once the painter has solved all the anatomical questions, he or she can harmonize the contrasts with washes of India ink and then apply the definite colors and tones.

Color and Synthesis of Animals in a Landscape

The color treatment when painting animals in the landscape will be different depending on the medium you

Drawing and study of a cow with a watercolor pencil.

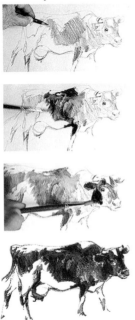

are working with. For instance, watercolors, requiring a very precise positioning and drawing, need careful coloring. The lines and colors should be harmonious, going over only the significant forms and characteristics.

When painting in oils the shape and color need not be predetermined, but the crea-

Watercolor painting of a duck.

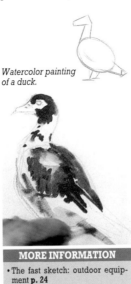

Integrating the Animal in the Landscape

When painting animals in a landscape, you may choose to make the animal a major element by painting it in the foreground, or you may integrate it further back within the landscape. This second solution is achieved by carrying out a careful analysis of the forms while treating the animal as if it were just another element of your painting.

Example of how animals can be completely integrated into a landscape.

MORE INFORMATION
• The fast sketch: outdoor equipment **p. 24**
• The quick sketch in lead pencil **p. 34**

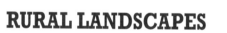

RURAL LANDSCAPES

Landscapes cover a large number of environments that are differentiated mainly by their treatment of the subject.
However, the rural landscape contains much of the work of man: buildings, gardens, livestock, etc. The artist does not need to travel far to reach a suitable subject. The rural landscape can be found on the outskirts of any city or town.

Composition and Background

Along with all the other variations of the landscape, the human elements in the landscape give rise to a particularly interesting creative opportunity. In

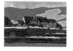

Creating a sensation of depth through the composition of planes.

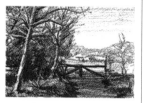

L-shaped landscape composition.

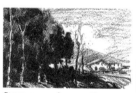

Strong sense of perspective in a painting with a triangular-rectangular composition.

rural landscapes, masses of color form the planes of the earth, since here importance is attached not to the forests but to the agricultural land and small features of the terrain. The structure of a rural landscape usually has more need for the vanishing lines of perspective rather than the perspective achieved by superimposing planes.

Important Areas of the Painting

There are three distinct planes in the rural landscape: the general plane, the midground, and the foreground. How these planes are combined will depend on the artist's intentions. In the same way as the human eye can select the points of interest in a subject, in rural landscapes the same interest occurs once the desired depth has been chosen. Including details in the foreground, while gradually

Composition of depth after adding a tree in the foreground.

leaving others more undefined, emphasizes the more important ones.

In this subject, agricultural land becomes important be-

Watercolor with a rich base and detailed additions.

cause of the elements it includes. Depending on the technique used, the details are developed in different ways. The watercolor technique allows the artist to paint an indeterminate base on a wet surface and then add details as the picture dries, such as branches, grass, bushes, or the chromatic differences of the terrain such as the shadows on the tilled land.

The Importance of the Motif

Although the rural landscape is a subgenre of the subject in question, it requires a special effort to synthesize the variety of elements within the scene. Generally speaking, on the outskirts of any city, where we start to see farmland, fruit trees, and large expanses of land, the diversity of elements in the subject becomes almost infinite. The subject must

Animals in a Landscape
Rural Landscapes
Trees in the Landscape

49

The initial sketch should be a synthesis of the elements to be included in the painting.

therefore be harmonized by what we choose to include.

The subject for the painting is synthesized through the main lines, so we need to choose those points on the terrain that establish the perspective or the different position of the planes such as the dividing line between different crops, electrical posts, rows of houses, etc.

Once the general layout of the subject has been completed, the location of the elements will emphasize the importance of the main motif. This is the moment to delete any unnecessary components that may interfere with the overall composition of the painting.

Planes and Color

Irrespective of the chromatic range being used, you can see

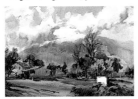

Although the foreground may be formed by "warm" elements, the cool colors become stronger as the subject retreats into the distance.

how the atmosphere acts as a filter for the objects as they recede into the background. The tendency of a warm color that retreats into the distance is to enter another range of cool colors. For example, a large wheatfield will have a richer warm tone in the foreground

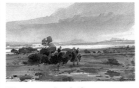

The warm colors in the foreground gradually disappear in the middle and background.

and then will tend to become cooler as our eyes move into the background. So it is not only perspective that defines the third dimension of a painting, but also the right use of color is often decisive for the location of the different planes.

How to Use Different Techniques

When painting a landscape in oils, the initial underpainting defines the broad planes, general countryside, expanses of land, fruit trees, etc. This is done prior to the detailed work, which is added later. If a certain color from this initial work is to be maintained, it should be visible through the subsequent layers of color and seen between the details that define the forms.

In watercolor it is essential to carefully position the sub-

In oil painting, the initial roughing-out defines the overall composition.

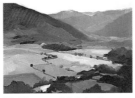

Working on and defining the details is left for a later stage in the painting.

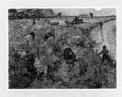

Van Gogh, The Red Vineyard.

Van Gogh and the Landscape

In this painting, Van Gogh creates a landscape through the use of planes. The perspective is created by the reduction in size of the different elements that appear in the composition. Note the use of contrast produced by the forms and masses of color.

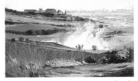

This pastel painting perfectly combines all the elements present in the landscape: composition, depth, color, light, etc.

ject in pencil. Due to the transparency of this medium, dark colors can always be seen through the lighter ones and the artist must foresee which areas will be the lightest so he or she can leave them blank.

MORE INFORMATION
A clear sky **p. 86**
A stormy sky **p. 90**
How to paint foregrounds **p. 94**

TREES IN THE LANDSCAPE

In order to develop a landscape correctly, we need to carefully study each of its elements. Irrespective of how the subject is to be treated, we should be able to distinguish the wide variety of trees that appear. Some are perennials, other deciduous, some are fruit trees and others wild bushes. The growth pattern of each kind varies and the artist must study the structure of the branches so that the areas of leaves help identify the plant. Drawing the trunks and branches in pencil is great for learning how to synthesize both the bare branches in winter and the leafy ones in the spring.

Proportioning and Perception

To paint trees correctly, the artist must be familiar with the lines that form them. By carefully studying trees, you can see that there is a close relationship between the proportions of the trunk and the foliage. You need to observe how many sections the trunk consists of in order to establish the right proportions between the top and the

An olive trunk.

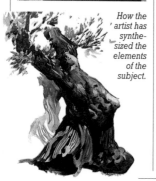

How the artist has synthesized the elements of the subject.

Sketch of leafless trees, with a compact treetop.

trunk and between the different trees in the painting.

To develop the volume and the structure, it is always advisable to start with a simplified concept that summarizes the subject, using as small a number

Artist's concept of the subject presented below.

Photograph of trees with the differences in structure and foliage.

of lines as possible. This initial sketch can then be elaborated upon by adding the branches and the leaves.

Foliage

Once the basic structure of the branches is in place, one way of representing the leaves is by understanding the varied density of the foliage.

The density of the branches and foliage will decide the visible spaces between them. The denser the foliage, the less visible the branches will be.

When painting a tree, the artist notes the density of the foliage by the degree of transparency existing between it and the space showing through.

Correct sequence for painting a tree.

Rural Landscapes
Trees in the Landscape
Trees in the Landscape: Branches and Leaves
51

First, the main areas are filled in without detail. The details begin to appear as the volumes approach the observer's vision. In order to suggest volume, two greens of different intensity can be used, which increase as they approach the foreground.

Painting a Tree

The first stage is to position the subject in such a way as to achieve the correct proportion between the top and the trunk.

This placement is then entirely covered with the color of the background, "invading" the areas where the foliage is eventually to appear. In the case of oil painting, the artist begins with a dark color, a blackish green. If the tree is mainly luminous, a bright green with gray-blue should be used. The overall structure of the tree is then painted in this dark color, leaving only the large empty space for the sky.

The painting is begun after the different planes of depth are determined.

Reinforcing the Colors

We start with just three colors, which will include the background color, a medium green, and a dark green. The silhouettes of the leaves are combined with the background using the darker green. The lighter green is

How alternating chromaticism defines details.

Colors used to reinforce the chromaticism.

applied to create illuminated areas containing forms such as bunches of leaves, thus creating different planes. The background color is used to "empty" certain areas, helping in this way to create a three-dimensional effect.

Light green for the highlighted areas.

Dark green for the shadows.

"Empty" spaces created by the background color.

Determining the Finish

The degree of finish applied to the trees or group of trees depends on the distance from the observer. The closer the tree, the greater the definition of colors, details, and tonal variation in the branches and leaves.

As the observer's viewpoint retreats, the tree loses definition and contrast.

MORE INFORMATION

Different techniques for painting trees p. 12

Trees in the landscape: branches and leaves p. 52

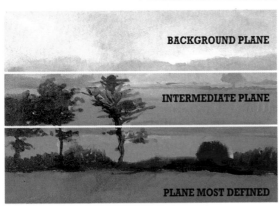

BACKGROUND PLANE

INTERMEDIATE PLANE

PLANE MOST DEFINED

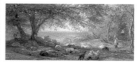

TREES IN THE LANDSCAPE: BRANCHES AND LEAVES

When painting a landscape, the effort made in studying trees will enable you to understand how to simplify the forms.

Painting a tree as the main subject is not the same as simply including a tree as just another element in the composition. The first instance requires careful attention to form and detail, whereas in the second, the forms are more general and show less detail, although, of course, the main features of the tree are still present.

A combination of forms that represent the trees, incorporated into the painting as a whole.

The Background

The composition of a landscape is often based on the distribution of the trees and the combination of masses of color they produce.

It is often difficult to distinguish between the background and the subject, especially when the emphasis is on the overall composition.

The distribution of the trees, although it may correspond to reality, is often manipulated within the landscape by the artist to arrange the shadows and volumes so they harmonize with the structure of the terrain.

A landscape with a composition developed in accordance with the trees in the foreground.

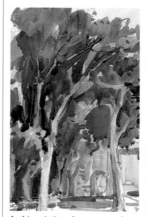

In this painting, the trees stand out among the rest as the main elements.

From Details to the Overall Treatment

An artist may decide to paint a grove of trees, only detailing those aspects that differentiate the particular kind of tree. These features include, for example, the kind of bark, the shape of the leaves, and their general appearance.

The trunk is painted in a general tone, emphasizing the shadows, though not too much of the detail of the texture. Detail is added once the general tone has been applied. The texture of the trunk can often be represented by lines and gradations, in which case the volume of the trunk is created by the play of light on the bark itself.

Samuel Palmer, Pleasant Shadows. *The branches of the trees frame the composition.*

Edward Seago, Norfolk Field in Winter. *Here the artist uses the skeleton-like trees to stress the wintry weather, loneliness, and silence of this snowy landscape.*

Trees in the Landscape **53**
Trees in the Landscape: Branches and Leaves
Detail and Perspective

A Thicket as the Overall Composition

The composition of a landscape starts with a synthesis of all the elements of the painting. From the initial approach to the final brushstrokes, a series of design decisions develop which, based on the color and the forms, determine the overall effect of the painting.

If you observe a landscape through half-closed eyes, you will see that the elements lose their definition and the entire composition becomes more unified. In the case of a thicket of trees, the chromatic density tends toward a uniform

In this landscape the thicket is blended into the whole.

mass. Beyond the mass of color that forms the thicket, the distant planes can be seen to contrast with the chromatic and tonal changes in the foreground.

The composition of trees is based on a uniform mass of color that brings the elements together. When working in watercolor, the surface of the thicket can be painted on a wet surface, varying the application of color to achieve different effects, i.e., if emer-

ald green is applied on the wet surface, different areas of darker greens and blues will spread over the wet area and blend together.

Details Within the Whole

A mass of color appears to be a uniform whole, with no individual identity. This is useful for introducing distant planes, yet on occasions there are elements that are left isolated among the broad masses of color, a solitary tree, for example. In this case, although we maintain the green chromaticism of the treetop, the chromatic effects should be reinforced, especially in those areas where two chromatic areas come into contact. The texture varies in accordance with the effect of contrast while the shadows of the isolated object also add an emphasis.

The foreground has been defined so as to differentiate it clearly from the rest of the painting.

Botticelli's Trees

Sandro Botticelli (1444–1510) had a special way of painting trees; in this work he presents the trees as columns, with detailed leaves painted individually.

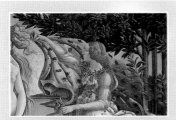

Sandro Botticelli, The Birth of Venus (detail). Galleria degli Uffizi, Florence.

Detail and the Proximity of Planes

As the plane comes closer to the viewpoint of the observer, the image as a whole begins to fade although the elements themselves become more defined. In most cases, after completing the layout of the painting, the underpainting already includes the different planes to be developed. It is over these that the details of the foreground are added. The chromaticism of the background is worked on first, then the colors and forms are gradually defined.

In the foreground, the details of the branches, leaves, and trunk become apparent. This is where a smaller brush is useful, together with more attention to the shadows, texture, and effects of light.

The variation of color between the tree and the whole produces a simultaneous contrast between both tonalities.

The foreground creates depth in relationship to the background.

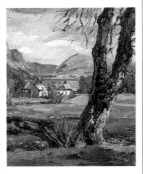

MORE INFORMATION

Different techniques for painting trees **p. 12**

Trees in the landscape **p. 50**

How to paint foregrounds **p. 94**

DETAIL AND PERSPECTIVE

In a landscape, all the elements have to be developed within the limits assigned to them. The structure upon which this occurs forms part of the interrelated planes, the planes of the subject being the reference points.

Both perspective by planes and by vanishing lines recreate the third dimension of the painting. This includes the correct use of color and the iconographical elements of the picture.

Drawing Instruments

In order to emphasize the sensation of depth of the different planes, importance should be attached to the drawing and tonal evaluation, which reduce the subject to a harmony of individual elements and major planes.

The drawing establishes the lines of perspective and the vanishing points. The basic layout of a landscape can be carried out with almost any drawing instrument, although the intrinsic properties of each instrument should be used to enhance the technique employed.

When you study the compatibility of the different techniques, certain mediums that at first appear incompatible can actually be suitable in combination. A clear example of this is the use of wax as a drawing medium, for wax repels water and leaves the

Drawing is of great importance for reinforcing the sensation of depth through different planes.

white of the paper free of any watercolor washes.

Working on Dimensions and Proportions

When painting a landscape, it is useful to study the planes that go to make it up. If you imagine it as a flat surface, the motif can thus then be transferred to the painting. Within the chosen format of the subject, the point of interest is determined to be the point on which the lines of perspective will converge.

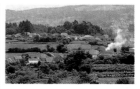

How to position the central focal point of the composition in advance of deciding on the different planes.

In many cases, the landscape is interpreted by means of the position of the different planes. Starting with the subject, first decide what the main volumes or masses of color are to be and reduce them to their outlines. Once the center of interest is selected as the reference point, it will be easier to decide the position of the different elements of the painting.

We mentioned three main planes in a landscape: the background, composed of the mountains; the middle ground, containing the thicket of trees which, at the same time, separates the foreground from the

Any instrument that can be used for drawing lines can be used for determining the layout, the drawing, and the perspective of the different planes of the painting.

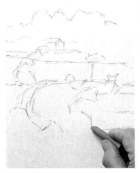

When composing, the artist takes into account the dimensions and proportions, i.e., the different planes.

background; and the foreground itself, which centers on the main theme of the composition.

From the General to the Specific

Based on these three planes, two distinct types of perspective are introduced: that created by the two more distant, superimposed planes, and that which develops in the fore-

The artist works on the background plane.
This completed, it is time to move on to the foreground.

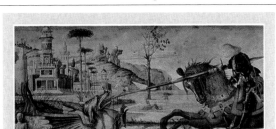

Different Planes in the Sixteenth Century

In this scene of *Saint George and the Dragon* (1502–1507), Vittore Carpaccio presents us with a landscape in which great care has been taken with each of the different planes.
The orderly fashion in which the trees and buildings are distributed focuses our attention on the horizon, thus separating the middle ground from the foreground.

ground in which the perspective follows a linear layout, with lines of perspective that retreat toward the vanishing point, i.e., the focal point of the landscape.

By calculating the proportions and adding the lines of perspective, the different elements are positioned on the surface of the landscape, their size diminishing in accordance with their distance from the observer.

MORE INFORMATION
Evaluating planes in pastels **p. 14**
The horizon line and the viewpoint **p. 38**

The Importance of the Foreground

The foreground is of fundamental importance in landscapes in creating a separation from the other planes.

The chromaticism we use will increase in brightness in the closer planes, which also involve more detail and textured work. In this plane, the detailed work presupposes a solid knowledge of drawing, forms, and the nature of light.

Although the initial color is the same for all the planes present in the painting, in this area we must apply more exact brushstrokes and avoid any ambiguity of color, bringing everything closer to the real colors of the subject. This color work, more meticulous in the foreground, is necessitated by the details of leaves, branches, bark, and grass.

When adding these details, we must bear in mind the underlying color, letting the color of the more distant planes to show through and reveal the overall distribution of color in the painting.

RURAL BUILDINGS, DISTANT PLANES

Landscape painting holds numerous possibilities for representing the elements in the landscape, both as to subject matter and form. The different elements of the landscape are used to balance the composition. This is why the observer welcomes the existence of reference points in the painting with which to identify.

Lastly, there exist many different ways of representing the most distant planes.

The painting starts with the background.

Defining the Background

The background may be approached by starting with a quick, thin painting in oils leaving the foreground for the later stages.

The arrangement of the motif determines the method to follow (in this case a mountainous landscape) and a stretch of land

Then we start on the mountainous plane as well as the foreground. Finally the details are added.

in the foreground sets the scene for the relationship to bluish, cool tones in the distance, which in turn helps to situate the middle and the foreground.

Planes in the distance must always be painted using a cooler range of colors than those in the middle or foreground. After evaluating the sky and the mountains in the background, the land line is placed into the painting with a warmer color.

It is advisable to clearly mark off the limits of the differ-

ent planes, at least when detailing the background. Where the land line starts, the earthy greens are painted using neutral color combinations.

Creating a series of forms that define thickets of trees and bushes.

Underpainting that Defines Forms

Distance in a landscape has its own form of expression. It is obvious that forms in the distance are smaller, but color also helps to place the objects, which, if far, tend to take on the general color of the background while those closer to us have a more distinct color and resolution.

Starting from the earth line and moving toward the mountains in the background, a series of forms are created to suggest thickets of trees and bushes, the most distant of which tend to blend into the background.

The colors that are to define the construction of the painting start as simple, dark shapes which, unlike the trees and other elements in the landscape, have geometrical forms defined by their plane and by the brushstrokes.

Suggesting Volume

Although we started by explaining how to define the architectural forms, the approach you use is primarily based on the variations in the different planes and the light that illuminates them. Studying the lighting of the painting, we can see how the light strikes the walls of the houses in different ways and how the rooftops cast a shadow on the supporting walls. With this, and a basic understanding of perspective, the houses and other buildings can be reduced to geometric forms.

In these buildings, you can see how the light strikes the walls and rooftops in different ways.

Many elements can be painted by using geometric forms with their own shadows.

The Medieval Landscape

The artist's ideal has varied throughout the history of painting. During the Roman and Gothic period, a landscape was unthinkable without obvious architectural references and it was almost always painted from an elevated viewpoint. In the Renaissance, the landscape was almost always the backdrop to the characters and buildings. Today, a rural landscape may or may not include buildings.

The Reflection of Color on Buildings

All flat surfaces, and especially those that are light-colored, are perfect for reflecting all the colors that surround them. This is why a landscape should never be painted in the colors the artist believes it to have, but in the subject's own, real colors that include the reflection of all the colors nearest to it. In landscapes, white is seldom used as a pure color. Considering that all colors are interrelated in accordance with their proximity, pure colors should seldom be

Clear colors are seldom pure. They always reflect their surroundings.

used, and when they are, it should be intentional, and for a good reason.

Brushstrokes and Planes in the Construction

Each brush has its own way of expression according to its design, and we should use the one that best suits the area we are painting. Soft-haired brushes are ideal for blending colors, while hog's hair brushes can take up a large amount of paint and create planes and masses of color that are well emphasized, while at the same time providing the texture associated with a stiff haired brush.

Changing brushes creates a wide range of textures and helps develop the different planes during the construction of the painting. This construction ranges from the purely architectural, which requires flat, straight brushstrokes, to the representation of treetops in the middle and background,

A textured brushstroke. The way to build up planes.

using a series of flowing brushstrokes that define the forms while letting part of the underlying color to show through.

A blended brushstroke. How tones and colors are blended on the canvas.

Balancing Color and Forms

The forms present in a landscape are seldom perfect; they always have slight deviations or defects that bring them to life. The color is always combined with the areas that these forms occupy, emphasizing the three dimensions by means of the play of light between one plane and another.

Claude Monet, The Wheat-field. This landscape is a good example of how to construct forms designed for the entire painting, not individually, as shown by the detail below.

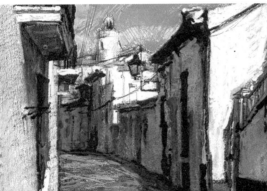

MORE INFORMATION

Composition in landscapes **p. 28**
Different planes and depth **p. 76**

RIVER AND POND LANDSCAPES

Within the great variety of landscapes, water themes offer a wide range of possibilities, from the source of a river, abundant with vegetation, ponds, and reeds, to the depiction of vast rivers and all their associated elements.
As regards the pictorial aspects, water has always been a problem for beginners, so it is advisable to learn the possibilities that this theme offers. Observing the subject and the work of other artists will enable you to understand an aspect that at first seems extremely difficult.

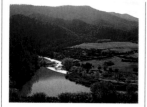

The River and Pond Landscape. Theme and Composition

Within the composition of a landscape, a river is never included as an incidental feature. It has to be an image that has attracted our attention and irrespective of whether it is the main subject of the painting or an addition, the river will influence the entire painting.

The composition of a painting that uses water as its theme is always divided into at least three parts: the water itself and two banks or shores.

When a painter observes a mountainous landscape, the distribution of the masses of color and the composition correspond to the distribution of the elements. In the case of a river, however, the line of its banks strongly influences the composition and becomes the main feature of interest. The artist will try to balance the river with the remaining elements

The composition of landscapes with water has at least three parts; the water itself and the two banks.

When drawing a sketch, the importance of the course of the river must be borne in mind.

The mass of the water has great importance when the composition forms are considered.

by the way in which he or she includes this new element.

Composing the Masses of Color Surrounding the River

Although we have seen that in a non-aquatic landscape the composition is designed in accordance with the balance of forms and color in the painting, when we are dealing with a landscape containing a river, the mass formed by the water is so emphatic that the rest of the elements depend on the form and color of the river.

The placement of the river depends not so much on the river itself as on the surrounding planes. The elements in the painting fall into place depending on the subject, in such a way that the space reserved for the river at first be-

Following on from the previous layout, the large area occupied by the water must be contrasted against the other elements.

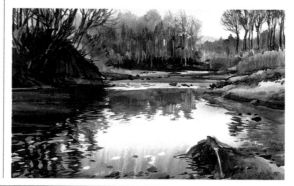

comes a neutral element that requires elaborating as the painting progresses. Water should reflect the objects that surround it, such as the trees, sky, rocks, etc.

The Palette and the Color

According to the chromatic range we have chosen, the tonality of the landscape will have different tendencies: the warm, cold, and neutral ranges of colors can all be developed within the subject of the landscape.

A painting is not only a composition; it is also color and light. Sometimes, the atmosphere is reflected more faithfully in the painting than by the subject itself, so it is up to the artist to ensure that the atmosphere of the landscapes is developed through the use of color. Once the right chromatic range has been chosen, the tonal values of the lights and darks of the subject are established. It then becomes possible to establish of the colors reflected on the water.

Three Levels of Development. Trees and the River

In a simple approach to a river landscape there exist three levels of development: the background, comprising the sky, mountains, or distant trees; secondly, the land edges that surround the water, such as open fields, trees, etc., and lastly, the river as a combination of reflections—an abstract reflection of the nearby colors. When painting a landscape, first the overall chromaticism is established by generally covering the canvas. As the middle ground develops, some of the elements will be reflected on the water. Sometimes a few simple brushstrokes are all that is necessary to reflect the color of the sky and the elements along the banks of the river. On

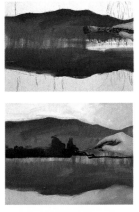

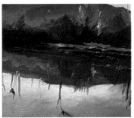

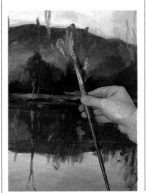

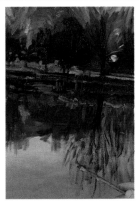

A sequence illustrating the process of creating a painting with water as the main element.

other occasions, the trees and their reflections in the river are developed simultaneously.

Lights and Shadows

Depending on the position of the landscape to the sun, the backlighting can become an important part of the composition. Lights then become the main pictorial element by outlining objects and thus becoming a more important element than the color itself. Or, with the source of light behind us, the objects and their reflections may become important. The chromatic and tonal contrasts alternate and more luminous colors must be used.

Reflections at Night

Adam Elsheimer, Flight to Egypt (1609).

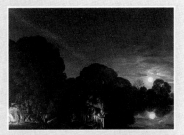

The painter presents the subject as a landscape at night, in which the composition in the shape of an arrow is carefully distributed among the three points of light present in the painting. In this case the river mirrors the night sky.

ROCKS IN A LANDSCAPE

Rocks are very common elements in a landscape painting. A landscape does not necessarily have to include all of the elements of nature that ordinarily cannot escape the painter's attention.

All the elements of a landscape painting can be reduced to schematic lines, and the geometry of nature's accidents can perfectly well be identified by means of light and color.

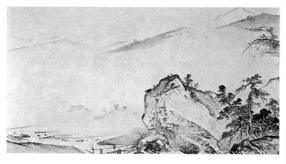

Rocks may be expressed with simple lines, but these should highlight mass and weight.

Scheme of a rocky landscape.

Geometry and Stones

All objects can be reduced to simples lines. A scheme depicting large rocks and even mountains would consist of planes of color masses, and it is precisely during the initial roughing-out that these objects acquire solidity, through the development of color planes. A rock is easy to understand if we deal with it as an object made up of flat and round planes defined by light. Therefore, the planes' colors will be seen as variations of a single color, which the artist has to mix on the palette in order to obtain the rock's color.

In certain occasions, texture and light become critical elements in stone painting.

Volume and Light

Rocks, mountains, all objects can be reduced to basic geometric shapes. The volume of an object in a painting depends on both how far away it is from the observer and the source of light.

The atmosphere separating us from an object acts as a filter and makes distant objects take on a coolish hue and a flattish appearance.

The way the rocks and stones in the foreground and middle ground are illuminated is decisive for emphasizing the volume of the objects. The rocks' shadows are not only cast over the ground and the face of the mountain. The light acts differently in each instance, creating distinct tonal planes.

The Foreground with Large Volumes

In this picture, painted in 1890, Degas has situated the large volumes in the foreground, using the principle of obtaining the weights of the different masses that make up the picture through color, the darkest colors being found at the bottom in the foreground.

The foreground in this case is an important compositional element which, in spite of its predominance, has not been rendered in detail since the painter's objective is to achieve a maximal contrast of light.

Light Envelops Objects

Colors may be tonal or local depending on whether the light is direct or indirect. When an object receives frontal light, its volume is barely discernable, and the shadows are minimal. Therefore, the color displayed is the object's own specific color, the local color. On the other hand, when the light is indirect or reflected, the object undergoes a series of tonal alterations caused by the shadows and reflected colors of the surrounding objects.

A study of the color of bodies: A, with lateral lighting. B, with direct and frontal lighting. C, with light reflected off a colored object.

A

B

C

MORE INFORMATION
Composition in the landscape **p. 28**

The Light on the Subject

Light is an important element in the landscape because it emphasizes and differentiates textures and volumes. For this reason the landscape artist must bear in mind the importance of time of day when he or she is painting the subject. This is especially so when the picture is going to be painted over a number of sessions, since it is essential to maintain the same incidence of light over the objects as it was when starting the painting.

Unity in a Landscape and its Chromatic Effect

When the artist chooses a palette, it must be one that will relate to all the tonal gradations of the landscape. When the painter decides on the chromaticism of the palette, the subject's colors will have to be analyzed in order to be able to continue with the painting at a future date.

We could use the term "translate" to refer to the way in which the artist interprets the landscape's real color.

The rocks in this painting are influenced by the harmonic range chosen.

Likewise, if the painter decides on a tonal atmosphere enveloping the whole landscape, the colors will undergo an interpretation accordingly.

In this way, depending on whether the tonal atmosphere chosen is warm or cool, green will take on a more or less influential role. Shadows will also be affected: if you choose a warm composition, the shadows will, traditionally, take on a cool or bluish character, but maintain the general warm tone in their lightest areas.

Wet Rocks

You will notice, in spite of having settled on a definite chromatic range, that a color may vary in intensity where the object is wet. The tonality of stone and rocks intensifies when it comes into contact with water, so that when you paint rocks along the banks of rivers or those drenched by rain the tone of the color you are working with will move toward the chosen harmonic range. For example, an orange will tend toward red, or a gray toward blue.

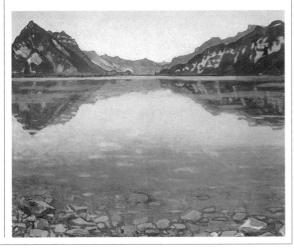

TECHNIQUE AND PRACTICE

WATER: RIVERS AND PONDS

Artists have always found water themes particularly challenging, and throughout history painters have discovered all manner of ways of interpreting the waters of rivers and lakes. Water is mainly a mirror of reflections. Light penetrates the surface of the water, reflecting both the objects nearby and in the background.
Water is even more pronounced by the movement of the wind and the internal currents of the rivers and ponds. Such movement or stillness is emphasized through the character of the light it reflects.

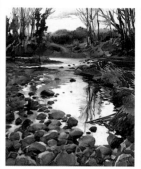

The movement of water distorts forms and reflections.

Movement in Water

Water is a living mirror on which light is reflected to a greater or lesser degree, depending on the way in which the water is moving. When the wind disturbs the calm waters of a lake, the clarity of the reflection tends to become ruffled. Then the reflection of the surrounding landscape becomes less distinct.

When painting water, it is essential to distinguish the movement of the current itself from the ripples produced by the wind.

When painting a landscape with water, the picture is first roughed-out in the usual way, including the reflections of the water. In mediums like oil or acrylic, the reflections can be painted to mirror the reflected objects themselves.

Greater care must be taken with watercolor; the distortion produced by the reflections on the water should be taken into account from the beginning of the painting.

Color as a Reflection of the Surroundings

No matter whether the water is moving or still, the colors of the environment are seen in the water, the shapes being more or less defined depending on the water's surface.

The representation of color in water is always more intense than in the scene itself, and the colors you use to paint the scene must also be used in the reflection on the surface of the water. Make sure that the vertical planes of the surface continue to reflect vertically, while taking into account the distortion produced by the distance between the object being reflected and the water.

Reflected objects not only reverse the shape of the image but also comply with the rules of perspective.

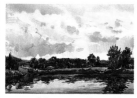

Calm water reflects objects with more sharpness than moving water.

How to Paint Riverbanks

There are many difficulties involved in painting a riverbank scene. This is because of the intermixing of the colors of the reflections and of the various objects being reflected. In principle, when resolving the image-reflection problem, the original image is the more defined one, while the reflection is seen as an variation of the original, no matter how still the waters may be. Even when the reflection is a faithful copy of the reflected image, there is always a slight change in tonality.

The areas between the riverbank and the water tend to be populated by weeds and rushes; they should be

Contrasts are accentuated in reflections.

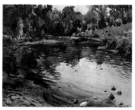

left until you have finished the other areas. If you have made a good preliminary drawing, it will be easier to locate the limits of the two planes. One way of separating the land and the water is through tonal contrasts; the bank in the area where it meets the water can be painted with darker colors, which, through contrast, will make the water lighter or almost white.

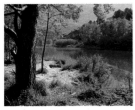

Photograph of a landscape in which the water is featured.

Using the example above, the artist has freely changed certain elements with the aim of improving the overall painting.

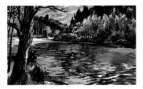

If you paint a picture following a cool, warm, or neutral harmonic range, the colors will never look muddy.

The Sky in a Reflection

In this picture, Pissarro created the surface of still water, in which the blue tones reflect the light of the sky that cannot otherwise be seen in the painting.

Pissarro, The Sea at Montfoucault, Fall.

Don't Muddy the Colors

The palette is where you organize your colors; it may occur when working on a specific area that the profusion of colors you are using ends up discoloring those that have to be kept unmixed. In fact, any color, no matter how muddy it appears, can appear to be pure next to another that is not, that is, there exists a law of color that defines the intensity of a color from the contrast created with other colors. In a landscape in which yellow ochres predominate creating a warm overall tone, a cadmium red would look extremely dark. Surrounding these colors with

siennas, umbers, and blues would make it appear even brighter. Therefore, a painting will not become muddy if you keep to the harmony of the chromatic range: water is always more intense when the reflections on it are painted with lighter colors than those used in the rest of the scene.

Use White Daringly

It is often said that white can ruin a color by making it appear pastel-like. This is true to some degree, but when white is used as a neutral pure color it can create foam in water, suggest the speed at which the water gushes over the rocks, etc.

Watercolor, on the other hand, does not include a white paint, which is quite logical if you consider that in this transparent medium white is obtained from the color of the paper. One of the most practical ways of obtaining white is to wet the areas you want to highlight by applying a solution made up of 50% water and 50% bleach.

White can be opened up in watercolor by absorbing the color.

A solution comprising 50% water and 50% bleach also provides white for watercolors.

MORE INFORMATION
River and pond landscapes **p. 58**
River and pond vegetation **p. 64**

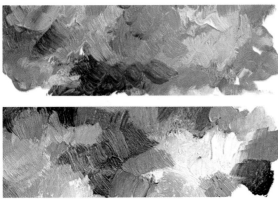

TECHNIQUE AND PRACTICE

RIVER AND POND VEGETATION

A unique world of plant life exists on the edges of rivers and ponds, different from the vegetation found in fields and woods. It is this type of vegetation surrounding the water that creates a pictorial barrier between the two planes of the painting. The variations of color and form become different forms of expression in the landscape, achieving a combination of forms, texture, and color.

Reeds

Along the banks of rivers and ponds there are wild plants that form a barrier that screens or even entirely conceals parts of the background landscape. These plants can often serve as an opportunity for creative expression and subtlety. Against a background of trees and earth colors or blues of hills, the reeds can appear as blowing in the wind.

Representing these elements requires a careful study. At the technical level, painting plants means to move into the realm of drawing because of the linear character that characterizes vegetation. The smallest brush must be used to work against the background, painting with yellowish green and orange strokes that represent the canes and other grasses, while the tip of the brush can be used for *sgraffito* and textured work.

When using the watercolor medium, it is advisable to work on a dry surface, so that the color will not spread and mix

Painting reeds and plants that grow in and near the water.

with the background colors. The canes can also be created by first applying streaks of translucent wax, which will repel the watercolor.

Expression and Subtlety

Wild flowers and plants can be painted using different techniques. The mass of color can be worked on as a whole,

and then the *sgraffito* method is used to create the textures of the various plants. Then all that is necessary is to add a few details such as flowers, leaves, and their shadows. The reflections of these plants on the surface of the water can be painted in the same way as the other elements.

This technique can be enhanced by employing a much more delicate style of painting, in which the brushwork highlights the volumes of the lighter, closer planes. This is achieved by slightly darkening sections of the canes with small broken lines, stressing the knots and joins of the plants.

In the watercolor technique, shadows are painted directly over the first application of color. The transparent nature of this technique allows for two layers of color to be blended by superimposing one over the other.

Trees painted by drybrush, using only a small amount of paint.

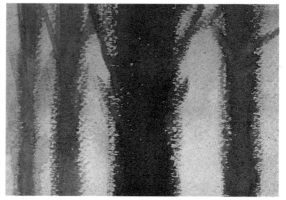

Water: Rivers and Ponds
River and Pond Vegetation
Wild Flora. Integration into the Landscape

65

Planes and Features

When painting near and middle planes, it may be necessary to superimpose different levels of the reeds. Superimposing different planes within a landscape is a regular procedure in landscape painting. It is also employed when the artist wishes to highlight the importance of depth or mass.

The plants found in these wet areas usually form a barrier. In order to paint this plane, we first use an indistinct background tone that is slightly darker than that in the foreground, while revealing some of the underlying colors. By adding other, more detailed planes, the artist begins the rendering of the plants at the level closest to the observer.

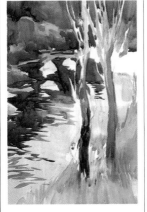

Short sequence showing how the reeds are superimposed in the foreground.

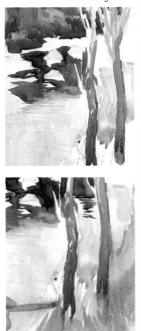

Vegetation and Movement

All the elements present in a landscape are subject to the effects of the wind, water, or snow. Vegetation moves accordingly, depending on the weather conditions. Plants will tend to lean in the direction of the wind, and the more flexible the plant, the greater the angle.

Plants that bend in the wind often do so from the middle, rather than from the base of the stem.

The effect produced by vegetation in movement is best represented by rendering fuzzy planes and bending the plants themselves.

Dürer and Plants

In this painting, Dürer, one of the greatest watercolorists in history, reveals his virtuosity and knowledge of botany. Watercolors allow you to al-

ternate wet and dry techniques in order to achieve works of great beauty and realism. In this painting, he first applied a wet, almost transparent base color. Then, using less water and acheiving a more opaque mix, he completed such details as the textures and shadows.

Plants on the Banks

Aquatic plants will usually grow in those areas of the river where the current is weakest. We will usually want to paint them using fine brushstrokes and making them lean slightly in the direction of the current.

Small plants on the riverbank.

MORE INFORMATION
Water: rivers and ponds **p. 62**
Reflections on the water **p. 68**

WILD FLORA.
INTEGRATION INTO THE LANDSCAPE

Each landscape has its own characteristic vegetation depending on the degree of humidity of the area represented. In landscapes, flowers are seldom painted in detail and sometimes are not included at all, as the terrain may be so dry that it only allows the growth of grass and bushes. Nevertheless, when wild flowers do appear in a landscape, they provide touches of color that help situate the remaining elements and indicate depth.

Example of a field full of poppies that has been beautifully represented by the use of complementary colors.

Roughing-out the Composition

The basic structure of a landscape depends on its composition and the chromatic balance employed. The development of the painting also depends on a correct roughing-out of the canvas. The balance of forms and colors will be arrived at as the painting progresses.

When beginning to define forms and colors, the artist must decide which combinations of complementary colors are to be used. This is important because if we are using a cool range of colors, rich in blues and greens, adding a strong complementary color can attract too much attention away from the overall chromaticism of the painting. For this reason it is advisable, during the initial painting, to bear in mind which areas will be developed using the complementary colors; for example, the flowers in the landscape.

Complementary Chromaticism

The play between opposites has long been a technique used by artists to draw the attention of the viewer to the landscape. Complementary colors are those positioned opposite within the color wheel; i.e., yellow is complementary to violet, red is complementary to green,

In this painting we can see clearly how the artist attracts the observer's attention thanks to the play on color.

and blue is complementary to orange. The complementary colors are those that present maximal contrast and which, when placed next to one another, produce a vibrant effect in the eye of the observer. Therefore, it is easy to see why a few touches of red in a green field will draw our attention to that area, thus making it become the center of interest.

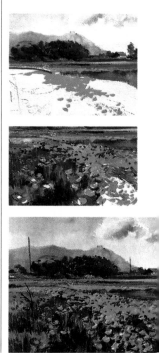

River and Pond Vegetation **67**
Wild Flora. Integration into the Landscape
Reflections on the Water

Superimposing Planes

In a landscape, the flowers can create a totally separate plane if we are not careful to integrate them into the overall painting. After having begun the painting, it is important to avoid creating planes of complementary colors that will tend to distract from the overall landscape, particularly in the flowers. Therefore, it is often advisable to pre-mix the colors on the palette in order to create planes that harmonize with one another.

Observation and Blending

Within any landscape painting there is no single tonality or dominant color, but a multitude of hues that represent certain

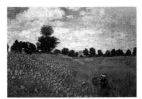

In this painting by Edouard Manet, The Poppies, *the plane forming the mass of colors is superimposed on the horizontal background.*

Composition of the superimposition of planes in the above painting.

features of the terrain. If we start with an entirely green area, for example a field, the lighter areas should tend toward ocher while an increase in the intensity of the greens with blue will suggest tall grasses and a sensation of lushness.

Reference Points and Light when Painting Flowers

Light reflects off objects and returns to the observer bathed with the color of the

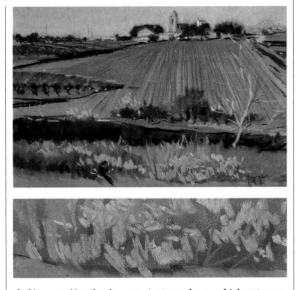

In this composition, the planes are clearly differentiated. The foreground stands out thanks to the flowers and grasses (see details), and becomes integrated into the landscape by being superimposed on the blended area.

object reflected. The distance between the object and the observer is occupied by the

Points of Light

In this landscape, Van Gogh has painted the flowers as small luminous points in a green wheatfield. The flowing brushstrokes stand out among the long yellow and green brushstrokes of the wheat.

Vincent Van Gogh, Edge of a Wheatfield with Poppies and a Swallow *(detail)*

atmosphere, which acts as a filter, reducing the intensity of color as it recedes into the background.

This filter acts in different ways depending on the intensity of the colors and the distance between them. In a landscape, the greens take on a bluish tinge in the distance, while warm colors become less distinct. Flowers are highly colorful, especially when they act as complementary colors. Poppies and other red flowers can be seen at a great distance and in the painting can be represented by tiny brushstrokes stretching away to the horizon. Lilacs, daisies, and white flowers are only visible in the fore- and middle ground, and tend to disappear as they recede into the distance.

MORE INFORMATION

Middle ground, general plane (difference between planes) **p. 32**

REFLECTIONS ON THE WATER

A landscape offers many possibilities when painting reflections that appear on the water. On occasions, the reflections are more important than the landscape itself, and these reflections depend on both the technique used and the approach the artist chooses.

The most popular mediums for the landscape artist are oils, pastels, pencil, watercolors, and tempera. Each has its particular advantages when rendering reflections on the water.

The Incidence of Light

The direction of light changes the texture and forms of the different objects. When light strikes an object, the object absorbs all the colors of the chromatic spectrum, reflecting only its own color. The intensity with which we see the object depends on the luminosity of its color. The ray of light that reflects off the object scatters in all directions, reflecting off other objects, particularly those that are flat and lighter in value. Incidence is the degree of inclination of the ray of light and its intensity will be determined by luminosity of the reflection.

Water is an ideal surface for reflecting objects, and the position of the object reflected depends on the distance it is from the water and other objects in front of it.

The incidence of a ray of light on an object returns only the color of the object itself. However, on a transparent surface, nearly all colors are returned.

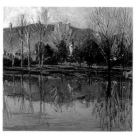

On any surface of water, the reflections distort the form of the objects.

Double Perspective

The observer's viewpoint can change the position of the reflection of the object. Let us imagine a plane divided in two, with the lower part a reflection of the upper part. We then locate a vanishing point, depending on the distance of the object from the riverbank. The reflected part appears smaller because the plane of the land hides part of the reflection on the water.

Different planes produce the same effect and superimposing them follows the same law of distances.

Waves and Reverberation of Light

On a flat surface of water, a small ripple caused by the fall of a leaf produces tiny waves moving out in a repetitive and circular pattern. Seen from above (a fairly uncommon occurrence), the ripples follow

Positioning of the reflections of objects depending on distance from the water.

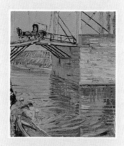

Vincent Van Gogh, Raised Bridge and Carriage (detail).

A Synthesis by Van Gogh

Synthesis in painting is beautifully represented by the reflections seen in a detail of Van Gogh's painting. The artist has painted a series of lines that vary in tone, increasing the intensity in the areas that include the reflection.

Wild Flora. Integration into the Landscape
Reflections on the Water
Mountains

69

When painting reflections, the most brilliant color possible should be used.

This sequence shows how the artist paints the objects reflected on the water, distorting the image and intensifying the whites and the shadows.

the laws of physics and spread out in perfect circles. However, seen from the shore, the laws of perspective spread the ripples elliptically, and that is how these are to be represented.

Variations on the surface of the water become points of light that distort the reflections of the objects. It requires skill to capture the reflections distorted by these ripples. The reflected image shifts slightly, and should be painted using the brightest colors available on your palette.

Watercolor painting is always more delicate, and should be taken into account when drawing the subject in pencil.

Shadows in Reflections

The light that strikes objects returns to the observer filtered by the atmosphere.

However, when an object is reflected on the water, the filtering effect of the atmosphere is significantly increased by the filtered reflection from the water, which intensifies the shadows and darker colors of the objects reflected.

Reflected objects appear darker in the water.

The effect of darkness upon reflected objects, together with the current of the water, produces a distorted image which in turn highlights the whites and the shadows. Note how this is taken into account in the sequence of paintings on the center column.

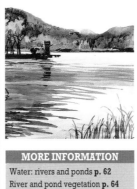

MORE INFORMATION
Water: rivers and ponds **p. 62**
River and pond vegetation **p. 64**

Reflection in Still Water

Unless it is a small pond, water is rarely totally still, so the mirror image it reflects is seldom perfect, usually distorted by tiny movements on the surface of the water.

In this painting by Lorraine, View of the Tiber from Monte Mario, *the reflections appear on still water.*

Synthesis in the Reflection

A reflection on water should be understood as a synthesis of the effects of light upon objects and the space they occupy plus their various extremes of reflected light.

This painting by Joaquim Mir, The Irrigation Ditch, *is a good example of the synthesis of reflections.*

A watercolor composition, showing a variety of reflections.

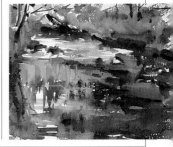

MOUNTAINS

One of the most important subjects in landscape painting are the mountains. These majestic forms against the background often dominate the composition, blending into the clouds or the blue of the sky. They are frequently the main subject of the painting, with their variety of textures (rocks, cliffs, valleys). Compositional possibilities include the mountain as subject or a landscape painted from atop a mountain.

Mountains are one of the most important features in landscape painting.

Color Influences According to the Season

In landscapes, the use of a certain harmonic range is dependent upon the season of the year. A painting of a mountain is the most affected by the different changes in weather, because of extreme changes in temperature at high altitude.

The cool range of colors is most suitable for winter landscapes.

When painting snowy landscapes in watercolors, the blue range plays the most important role.

Color in Winter

This season demands a cool range of colors, particularly whites and blues for snowy landscapes. Warm colors, however, should not be excluded in that they are essential in creating contrast. For example, in a snowy landscape, the contrast of the warm tones of tree trunks tends to intensify the coldness of the snow.

In the case of watercolors, winder landscapes require careful application of washes when developing the contrasts between snow, sky,

Mountain landscape painted with the neutral range of color.

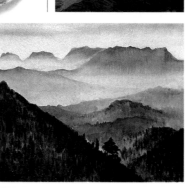

and other elements in the landscape.

Variety of Palettes

Any palette of colors can be used for mountains, depending on the type of mountain and its surroundings.

A rocky mountain landscape calls for a split palette of colors, including the warm and cool color ranges. A split palette is made up of complementary colors set out in equal proportions and including white. This allows for the use of neutral color for suggesting the distance, texture, and color of the rocks.

A landscape that is predominantly warm.

A cool palette is especially suited for painting distant mountains and surrounding woods.

A warm palette, including ochers, yellows, and browns is perfect for arid and hilly countrysides.

These suggestions are only a few of the alternatives available. Obviously, a landscape can be interpreted in any way the artist chooses, even monochromatically.

Reflections on the Water
Mountains
Wooded Landscapes. Shadows and Lights

71

A predominantly cool landscape.

Creating Volume

In a mountainous landscape, the overall volume is emphasized by the inclining planes, which also soften the vertical character of the mountains themselves. Nearby elements, such as rocks or trees, are painted after studying the light and shadows cast by these objects. Because these elements must be painted on the sloping face of the mountain, highlighting them with different colored outlines will help "plant" the forms on the mountain.

The more distant the mountain, the less individual elements need to be defined, as the overall view is what is most important.

Distance Weakens the Colors

Distance tends to weaken the colors and soften the tex-

The warm areas of the foreground become cool as they recede into the background.

tures. Groups of trees turn into green expanses, which vary as to species of trees by the use of blue greens and yellow greens, while meadow areas can be painted in ochres and umbers.

When the distance is even greater, the color becomes almost totally cool, any warm notes having practically disappeared. The few shadows

Depth is created by a changing relationship of the forms and the color.

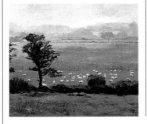

The cool colors increase in the more distant planes.

Warm colors play an important role in the middle ground.

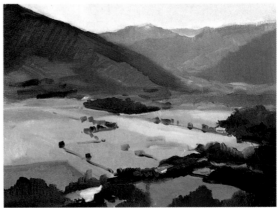

Background and Illumination

In this detail of *The Resurrection*, Bellini chooses to use a double play of light for representing the mountains in the background. The foreground uses luminous colors, as does the sky, while the mountain is backlighted and emphasized through the use of dark browns.

remaining should be created using tonal variations of the same bluish color.

MORE INFORMATION

Different planes and depth **p. 76**
How to paint foregrounds **p. 94**

TECHNIQUE AND PRACTICE

WOODED LANDSCAPES. SHADOWS AND LIGHTS

A forest seen from within has always been mysteriously attractive to painters; the play of light through trees and undergrowth, sometimes resting on hidden forest clearings, provides the artist with infinite creative opportunity.
Painting a forest requires the use of one's compositional imagination.

Light Filtering Through the Leaves

The palette necessary for painting a forested landscape requires a wide range of light and dark colors in order to emphasize the chromatic contrasts produced in the lighted and shaded areas.

The composition of a forest landscape should be centered on the interplay of lights and shadows that define the masses of foliage. The most important tree trunks should be correctly proportioned according to their distance from the viewer.

The light filtering through branches and leaves often forms patterns that can produce the effect of backlighting.

Different stages for painting the light between the trees:

1. The background color is arranged by areas, particularly in the upper part.

2. The planes that may include points of light are completed.

3. Tonal gradations for creating volume are added.

How to Paint Light Between the Trees

Framing or boxing distributes the masses within the framework. The recommended approach is to follow stages, as if working with consecutive planes.

In the initial composing of a painting, one should first concentrate on the background by using dense, dark colors in broad brushstrokes to indicate the foliage. Spaces should allowed between the strokes to admit the light.

Once the background is completed, the more distant planes are painted with their lighter tonal gradations.

Study the three stages shown above to acquire a practical grasp of this subject.

Backlighting and Shadows

When the background has been completed, the area requiring the darker and more intense colors such as the undergrowth and the treetops will become apparent. In painting these closer elements one should leave larger empty spaces than actually exist because they can easily be painted in later on if necessary.

The colors are mixed as the light filters through the trees.

Gustav Klimt, Fruit Trees. *It is clear that the intense background color prevents the landscape from stretching into the distance. Only the size of the tree trunks suggests depth.*

The sketch distributes the main areas of light and shadows.

The dark areas have been increased and the whites reinforced.

Backlighting is obtained by positioning objects or trees in front of the source of light.

Shadows and Tree Trunks in Landscapes

In a wooded area, the branches, trunks, and leaves of the trees are intermixed. If the structure followed in your initial drawing is correct, the painting and approach to the color should be fairly simple.

Now that both the background and the treetops have been put in, the tree trunks can be added to the landscape after defining the other different planes. If the green used is sufficiently deep, tree trunks can be added in the background, always using darker colors, and bearing in mind the reduction in size due to perspective. The closer the elements are to us, the fewer the number of trees and the larger they become. While the trees in the background are formed by narrow, flat, greenish brown brushstrokes, the colors in the foreground should be warmer. There is no beginning or end to these forms; they emerge from a base of thickets and grass in the foreground that can be painted last. The tree trunks should disappear above into their own leaves and branches.

Specific Brushstrokes for the Points of Light

Once the forested landscape has been entirely roughed-in, concentration on a logical approach to the light areas is required.

In order to paint the most illuminated sections of the landscape, the colors used must be light in value, while avoiding the use of white as much as possible. This is because white tends to weaken the intensity of colors. For example, most colors can be lightened by the addition of yellow without

Pure Color in Landscape Painting

Pure colors can be integrated into a forested landscape, particularly in areas of maximal darkness or light. Applying a pure color, just as it comes out of the tube, will maximize contrast when used with its complementary color.

weakening their brillance. Points of light should be applied only after the other colors have dried.

In watercolor you should always start with lighter colors, as darker colors cannot be lightened once they are applied due to the transparency of the medium.

Using Pure Color to Create Contrast

Pure colors can be integrated into a wooded landscape as areas of maximal darkness or light. Applying a pure color,

Development of the structure of the trees both in the background and in the foreground.

just as it comes out of the tube, will create maximal contrast when placed next to its complementary color.

With pure color and flowing brushstrokes, shadows, lights, and contrasts can be achieved.

Some brushstrokes are dense and pasty.

Forms are fused in the background.

Smear with brush holding only a small amount of paint.

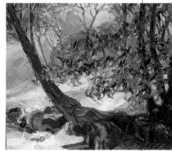

These brushstrokes build up the foliage in the foreground, while the background shows through.

MORE INFORMATION

Chromatic evaluation and the surrounding atmosphere **p. 40**
Resolving the whole **p. 44**

SNOW ON THE MOUNTAINS

Mountains are often covered by snow, which is especially attractive to the landscape artist as it provides is a theme that may be interpreted in broad terms or with a specific focus. The way in which snow is treated presents some exciting challenges. Artists, therefore, find it an excellent subject for experimentation and interpretation. In a snowy landscape the understanding of the use of space and the hues of luminous colors becomes all important.

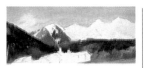

In snowscapes painted in water-colors, the snow itself is not painted; only the shadows and bare earth.

Different Hues of White

The palette used for a snowy landscape is not confined to white. The representation of volumes and the richness of hues inherent in snow cover the entire chromatic range of the palette the artist has chosen. Snow reflects all the colors that envelop it due to its colorless purity. Therefore, it is important to enlarge your range of colors.

The snow changes tone according to variations in the topography of the landscape. The reflections of the sky and nearby woods also influence the tonalities. An excellent medium for painting snow-covered mountains is watercolor, as its transparency offers a wide range of different hues.

The surface of the snow closely follows the topography of the land beneath it, and is

Color paints snow in reverse.

defined through the use of shadows. Useful hues are ochers, grays, blues, or greens, while white should dominate most of the surface.

Color as a Shadow in the Snow

When working in water-color, pure white is achieved by utilizing the bare white surface of the paper. A snow-covered expanse can also be painted in the dominant color of the sky, a bluish gray, for example. With this watered down color, the shadows of the terraced land or other land elements may be applied afterward. When the watercolor is dry, other elements can be introduced using darker tones.

Working with oils is somewhat easier, because of the opaque nature of the paint and its ability to completely cover over earlier work when making corrections. White, of course, must be painted on.

In oils, white is mixed with various tonalities for the painting of shadows.

Tonal Variations of a Snowy Landscape

Although snow is white, it possesses an extraordinary number of tones. One side of a

The white of snow can accommodate tones from the sky and other elements,

particularly in shadow areas and in order to achieve contrast.

Dark areas are never purely black. They acquire a bluish hue as a result of the reflection of light from the snow.

snow-covered mountain may be in the light and the other in shadow. Shadows cast in the snow are of a cold blue-violet color due to the reflection of the sky. Note that a little red can provide a touch of warmth to a cold shadow. The illuminated face of a mountain alternates between light umbers and ochers, becoming less distinct as the mountain recedes into the distance.

The different tonalities of a snowy mountain are usually varied. The artists usually leave blank areas representing pure white.

Wooded Landscapes. Shadows and Lights
Snow on the Mountains
Different Planes and Depth

75

Snow on Trees

Snow on a mountain takes on different tonalities that define the specific character and shadows of a terrain. The effect of snow on the trees alternates with the dark section of the branches and leaves.

Snow can be painted as masses of color, or, as in the case of watercolors, through an absence of color, especially on the upper part of the branches.

Also bear in mind that the weight of the snow will bend the branches down and this effect should be anticipated when organizing the picture.

In the same way that snow on land is defined mostly through shadows, with trees, the shadows are cast by the nearby branches. This should be painted using lighter tones the further away the branch is.

The Palette for a Snowy Landscape

Snow, as such, does not have a specific color, but is a synthesis of the reflections of objects and colors that sur-

The whites of the snow are expressed by the empty areas within the color.

Both on the land and on the trees, snow is always defined by the shadows created by different tonal variations.

round it. Any color can be used in a snowy landscape provided it falls into the chromatic range surrounding it.

The Grayscale in Tonal Gradation

One way of understanding the masses of tones that make up the snow is by lightening the tones of the shadows in the landscape. A series of

Snow does not have its own color; its tones are reflections of the colors in the landscape.

pencil sketches of the landscape to be painted will help to define the value variations of the shadows in the snow. Pencils of different hardnesses are useful, such as a 6B for deep blacks, a 2B for medium tones, and for soft grays, a 2H. An eraser can be used to pick out highlights by opening white areas where grays predominate.

Snow and the Gradation of Grays

In this panel, *del Maestro dell'Osservanza*, we can see Saint Anthony in the midst of a snowy landscape. As you can see, there are no pure whites, only tonal variations of bluish grays. The gentle gradations of grays are a perfect example of the wavy forms of snow.

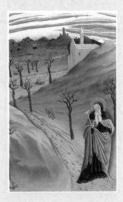

MORE INFORMATION
Mountains **p.70**
Climate and color **p. 84**

DIFFERENT PLANES AND DEPTH

In a landscape, the illusion of depth is created by applying the laws of perspective or by superimposing planes.
Superimposing planes in a landscape was used in Oriental painting, long before the Renaissance perspective made its mark on the history of art.
Linear perspective is achieved through the use of two or more lines converging at a vanishing point on the horizon. Depth in a landscape is also created by superimposing rises of hills or other elements off into the distance. The lightening and blueing of colors in the distance is another method.

Description of the Foreground, Middle Ground, and Background

Depth in a landscape is highlighted by superimposing different planes. The nearest plane, or foreground, is the object closest to the observer. Positioning this plane includes details and the definition of textures. Colors used in the foreground should never be pale in color; therefore, any gradations must be painted using the fairly intense colors of the same chromatic range or complementary colors, bearing in mind the new colors, mixed in the eye, this might produce.

The middle ground describes the general planes, which extend beyond the foreground, and can contain specific forms such as trees and houses (though not in great detail). Objects in the

Sensation of depth produced by the wings in the theater.

Layout of the superimposition of planes in a theater set.

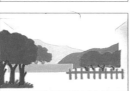

middle ground, seen from a vantage point, tend to diminish according to the distance. In this plane the colors should be fairly strong, but without too much variation.

In the background the forms are seen in a more general way, where only the large shadows stand out, blending their color with whatever chromatic range is being used.

Chromatic Variation and Distance

The subject has a certain depth within the landscape, in part due to the horizon line and in part due to the artist's viewpoint. Depending on these two factors, the sensation of depth created can be quite effective.

The space that separates the horizon line from the observer can be divided into as many planes as are required. Each line of objects, such as a forest, a tree in the foreground, or a mountain in the background, establishes a different plane in the painting.

The artist's palette must be adapted to each of the planes, because as the planes recede into the distance, the colors fade due to the effect of the atmosphere.

The warmest colors tend to become pastel-like when mixed with white in an opaque technique, and more transparent in

Tonal distribution of planes in the work by Emil Claus, Beside the Road.

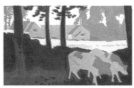

Each plane has its own tonality.

water-based paints with the addition of water. Cool colors will often appear brighter and will tend to be more homogeneous.

The Atmosphere as a Filter

The color of the objects, and therefore of the landscape itself, depends on how the light strikes them and reflects them toward the observer. Thus, if there exists a filter between the subject and the artist, the color will change accordingly. This is why dominant colors used on the palette, whether they be cool, warm, or neutral, play a similar role on the canvas to that played by the atmosphere in the landscape. Choosing a particular chromatic range is necessary in order to create a desired atmosphere.

A cool chromaticism will always seem lighter in the foreground. Also, always add some warm colors to otherwise cool atmosphere in the distance.

Relationship Between the Horizon and the Sky

In the relationship between the horizon and the sky, the chromatic limits of the distance are rarely clearly defined. There is a meeting point between the two that can be defined by the colors used. The solution is to gently blend the area between the background and the sky, while at the same time dividing them through the use of color. A soft-haired brush is usually used for blending colors.

Watercolors allow the artist to blend colors on a wet surface, controling the effect with a piece of blotting paper.

Watercolors allow gentle, gradated blends of color between the masses that form the landscape and the sky.

Using the same principle, warm colors, such as red and yellow, can be included on a cool palette.

Using White and Perspective

In opaque paintings, using too much white always means that part of the luminosity is lost.

Colors should not be lightened with white in order to create the effect of distance. This same mistake, which can produce undesirable results in certain cases, can be effec-

tively used to establish the distance of certain objects.

Certain colors such as red, when mixed with white become pink, which can be avoided by mixing in a little ocher or umber.

White has been used here to create an atmospheric effect.

The atmosphere is present between the landscape and the observer, acting like a color filter.

MORE INFORMATION

Middle ground, general plane (difference between planes) **p. 32**

Detail and perspective **p. 54**

SUNRISE AND SUNSET

Landscapes display different aspects of nature during any season of the year or time of day. All landscape artists are aware that there are key moments throughout the day when the sun illuminates the landscape in a desirable way; so much so that occasionally the luminosity of the sky becomes the main feature of the painting. Using the right colors enables the artists to represent the precise moment they have chosen to paint. Both sunrise and sunset last only a short time, so the artists must use their memory to recreate the splendor of the moment on the canvas.

Sunrise and sunset are spectacular moments of the day due to the luminosity and the chromaticism in the sky.

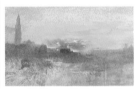

The light comes at an angle in this cloudy afternoon scene.

From the Chromaticism of the Sky to the Application of Color

There are many moments throughout the day for painting skies, yet sunrise and sunset are ideal moments for capturing that moment with color.

The color of the sky can vary enormously, depending on the atmospheric conditions. A clear sky during the daytime is painted using tonalities such as cerulean blue, white, cobalt blue, and, in certain cases, red or umber. These colors take on additional hues as the sun goes down, so that reds and yellows, together with cobalt blue should be added to the other colors. Naturally, the effect of the sky will influence the colors of the landscape.

The Importance of the Moment and the Light

Because sunset and sunrise last only a short time, it is advisable to photograph them so that they can be used as a reference

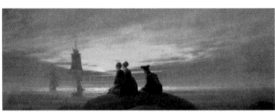

Sunset or sunrise offer a wide range of possibilities to the landscape artist.

later on. However, no photograph can capture all the subtle hues that occur in nature.

Color saturates both shadows and highlighted areas. When constructing the layout of a painting, it is important to indicate the brightest areas and the darkest shadows. Once the subject has been drawn in pencil, the artist should outline the parts of the landscape that will be touched by the sun's rays. These sessions commonly take several days, requiring a return to the spot at the same time each day to maintain a consistent palette.

Comparing Values and Highlighting the Whole

When painting a landscape at dusk, the entire subject

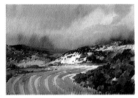

W. Turner, St. Gregory Seen from the Customs House. A sky saturated with medium colors.

should be quickly evaluated, assigning tonal values to each area of the picture. If the light is coming from the lower right hand side, the shadows corresponding to objects and land features should be immediately added according to the direction of the light source. Once the effect of the light has been incorporated into the painting, the artist can then experiment with the right chromaticism for each area, including the effects of the light in the sky, the play of reds on the horizon line, and the gradation toward cobalt blue in the upper part (if the source of the light is in front of the painter).

All the values of the painting, both tonal and chromatic, should be compared with

A simple layout for locating the masses of color.

the whole, so that if the illumination of the sky changes, this will influence the shadows and the luminosity of the objects.

Monochrome Sketches and the Center of Interest

One may theorize about landscapes, but practice is the

First, the canvas is painted with warm colors.

The dark blues dominate the tonality of dusk.

The light from the side affects the color of the mountains.

Sunset saturates the colors.

Seurat, Sunday Evening on the Isle of the Grande Jatte. *(detail)*

ows, although both areas are also rich in color.

most important part. When painting a landscape at dawn, it is very helpful to make monochrome sketches to achieve a tonal synthesis. The different grays will indicate the places of maximal light, and those that require the most attention. A flat stick of graphite and a notebook are sufficient for this work. Holding the stick flat, indicate the composition quickly by twisting it on the paper. The grays of the darker areas can then be suggested, plus a gentle gradation in the sky to indicate the area of maximal illumination. Graphite is quick to work with and the grays are easily produced by varying the pressure applied to the paper.

Tonal Gradation of the Sky

During the time the sun is above the horizon, the sky

A monochromic representation of a landscape allows for greater objectivity and provides guidelines for studio work.

Seurat and the Evening

Seurat, the great theorist and artist, painted this study with his intricate technique and captured the vibration of the colors at dusk. Note that there is a sharp contrast of light and shad-

takes on a large number of different hues.

Facing the light source, the clouds become saturated with reds and yellows, and the horizon line takes on an orangey luminosity that is offset by the gradation toward cobalt blue on the upper regions. If the light source swings around 30 degrees or so to the left, the sun will have disappeared, but the combination of violets, reds, and yellows will show through on the objects and features of the terrain. Objects can often be more easily distinguished in this phase as the light comes from the side and ends the effect of backlighting.

The sky is enriched by contrasts on the horizon.

MORE INFORMATION
The sky and its color **p. 80**
Depth and color **p. 82**

THE SKY AND ITS COLOR

One of the most important elements in a landscape and the source of light for forests and other elements in the subject is the sky.
Sometimes bright, other times tinged with storm tones, the theme of the sky is dealt with in each painting in a different way and there is no formula for painting it. The sky in a landscape reflects to a great extent the painter's artistic capability, since the sky is one of the elements that the realist painter uses to demonstrate all his or her ability in chromatic blending and color mixing.

Executing a landscape outdoors allows the artist to capture the colors of the moment.

The Color of the Sky According to the Time of Day

In a clear sky, the chromaticism varies throughout the day, ranging from cerulean blue to a deeper cobalt blue, and, depending on the sunlight, this blue can tend toward white, yellow, or red.

When the sun is directly above us, at midday, the sky

A midday sky.

At this time of the day, the maximal source of light is directly overhead and, accordingly, the shadows are diminished.

A study and composition of clouds.

appears to be uniform in color, and a mix of cerulean and white could suffice to cover it, without the need of any chromatic variations.

As the sun goes down, we can add a touch of cobalt to our palette for applying in the highest areas, plus a tiny amount of pinkish and orangish tones for the horizon.

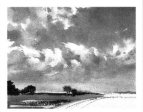

Integrating the sky and landscape.

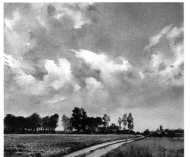

These celestial colors contain many warm and cool tones, depending on what season of the year it is and the time of day. It is recommended to always mix your colors on the palette so that you control the result before you apply them to the colors on the canvas or paper.

Influence of the Sky on the Landscape

The light that originates from different objects is the result of the reflections from stronger light sources. The sky above a landscape is nothing less than a reflection in the atmosphere of the light received from earth. For this reason the sky and the earth take on an identical chromatic unity.

The predominance of a specific harmonic range in the sky influences all the objects in the landscape. If the sky is painted in gray colors, this same tone will reappear even in the brightest areas of the landscape.

Any alteration of a harmonious chromaticism involving the sky and the earth beneath, such as painting a bright sky over a dark landscape, or a cool landscape with a sky in which

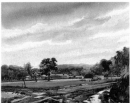

The tonality of the sky can be recognized in the reflections on the ponds and puddles. There is a chromatic unity between the sky and the landscape.

warm colors predominate, are the result of the artist's imagination and have nothing to do with the laws of nature.

Painting Skies

There is no such thing as a single technique for painting the sky, because it depends on the taste of the artist. He or she can use a soft wide brush to apply a broad flat tone. Mixing the chosen color with white, the artist begins to tone the entire area adjoining the horizon with sweeping strokes, blending the paint with the previously painted areas, while leaving the underlying layer partially visible. Several reddish, hardly perceptible tones are added in the lowest areas and are then blended into the background. The violet colors are added to the higher areas and are then softly blended, so that they do not attract too much attention.

Giorgione, Landscape at Dusk (detail).

The Color of the Afternoon

In this landscape at dusk, Giorgione knew perfectly well how to use the play of lights and color by adding some blue tones in the background and some subtle orange in the lowest part of the sky.

On the left, gradated with white, the color becomes opaque.

On the right, the addition of turpentine creates a transparency that enables glazes to be developed.

Warm and violet tones must be added to a gradation of the sky.

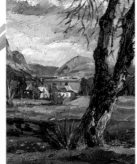

Gradation with blue and white.

Light Establishes the Clarity of the Whole

The clarity with which the elements in a landscape are defined depends on how much light they receive and the distance they are from the painter. A clear midday sky enables the artist to paint a landscape in which the visual limitations are determined by the planes between the horizon and the foreground. In this case, it is for the painter to decide how clearly he or she wants to define certain objects as the center of attention by emphasizing only the more interesting elements and leaving the rest less finished (and therefore less distinct).

In other circumstances, such as when there is fog or low clouds, elements beyond the middle ground become almost indistinct owing to the reduction of light. Distant colors lose their brilliance and the background planes and elements must be painted more fuzzily and using a maximum of the color that corresponds to the overall atmosphere.

Painting an atmospheric color blend.

Blending the sky with a part of the mountain color.

MORE INFORMATION

Different planes and depth **p. 76**
Sunrise and sunset **p. 78**

TECHNIQUE AND PRACTICE

DEPTH AND COLOR

Sometimes, when you look at the horizon, it is possible to draw clearly differentiated planes such as a line of trees, a series of hillocks, fields of crops, etc. However, frequently such elements are not found in a series of successive planes. If you look at landscape overall, you will see that planes as such do not really exist, but are merely a reference in the form of a colored mass established by the painter to use as a guide when composing the painting. Color and its value, according to distance, can also be a factor when determining the planes.

The effect of atmosphere on the subject.

Atmosphere and the Palette

All colors, as they recede into the distance undergo alterations due to the existence of the atmosphere.

The most significant change is the way in which colors take on a bluish tone. The reason for this is that the colors of objects pass through a layer of the atmosphere and reach the viewer with a greater saturation of the color blue, depend-

Before commencing to paint the effect of the atmosphere, you must first apply the local colors without the use of white.

ing of course on the density of the atmosphere at the moment.

A pure white turns to cerulean as it loses its brilliance,

Three tonalities indicating three planes.

green and ochre take on bluish and violet hues, while pure greens are mixed with ultramarine blue as the landscape recedes into the distance. Warm colors like reds and earth colors take on the appearance of having been mixed with white and a touch of blue. Dark greens in the shadows gradually become grayish greens with violet hues.

Painting Planes Through Clouds

The procedure consists of gradually developing clouds against a sky by blending in the color until it is almost opaque. The top of a cloud always appears denser and more opaque. The farther away the shapes are, the more undefined they become, to such a degree that they often appear to merge with one another.

The foreground, on the other hand, must be devoid of whites and the forms should be well contrasted by stressing

The colors begin to blend with the white but without breaking up the forms.

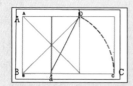

The Golden Section and Depth

The golden section derives from ancient mathematical studies of space in the quest for a perfect proportion. This system of dividing a space up is effective for weighing the masses of color and shapes on a plane. It is not difficult to understand, since it consists of dividing the surface of a painting by taking into account the measurements of the canvas (height and width). This method, used by artists from classic times, enables the painter to distribute objects in a harmonious way even though it may not be a faithful reflection of reality. In addition, it helps you to understand the most logical way of positioning the different objects on the different planes according to their esthetic balance.

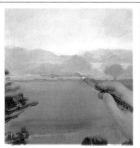

Some forms can be made out in the fog.

the light by means of the object's own color, that is, a green object will shine more when we apply paler greens, mixed with yellow and ochre, and the brown objects will be highlighted with oranges, and thus successively.

The Clouds in the Middle Ground

In order to achieve good results when creating depth through color, you have to bear in mind the location of the objects that appear on different planes, their texture and body, and the way in which they affect the planes behind them.

An overcast sky may take up only one part of the painting; it is not too difficult to resolve when the clouds are high up in the sky, but when clouds cover part of the middle ground and background, the challenge of painting them becomes more demanding. Depending on the density of the clouds, they generally blend into the surrounding atmosphere.

The General Plane and the Elements Near the Horizon

From the point of view of the observer, up to the horizon line the successive planes and color gradations indicate the distance and the location of the intermediate planes. The forms and masses of color that comprise the foreground are more defined than those in the receding planes.

If your horizon line is at eye level, you will notice how objects, such as trees, rocks, and so on, tower over the observer when they are in the foreground and tend to gradually reach down to the height of the horizon line as they recede

Warm and violet hues.

Tones are heightened in the foreground.

into the background. If, on the other hand, the observer is standing on a hill, the height of the most distant objects will be below the horizon line.

The color of objects alters as they recede into the distance; for instance, a red plane in the foreground would contain earth tones when seen in the middle plane and would appear almost violet in the distance.

A second blending of the background.

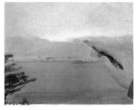

Accentuating the contrast in the foreground.

A landscape with an accentuated atmosphere in the middle ground.

MORE INFORMATION

Landscape composition **p. 28**
Different planes and depth **p. 76**

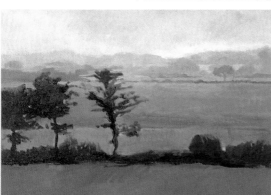

CLIMATE AND COLOR

A landscape acquires a particular chromaticism according to the season of the year. In the fall, the fields and landscapes take on earth colors with some neutral greens; spring turns them into bright greens and lively colors that illuminate the scene; in summer the colors turn more yellow, some turn darker while others become lighter in tone; in winter the colors of a landscape are decidedly cool.

Each Season Has Its Own Atmosphere

The color of a landscape always depends on the intrinsic color of the earthly elements and the intensity of the sun. These two factors are fundamental for understanding the palette to use in each of the four seasons.

Each season has its own particular temperature, light and color. If the painter is aware of the color effects of each season, it will be easier to paint a landscape and give it the appropriate chromaticism.

The artist has to observe the character of the place to be painted. In a dry, drought-ridden climate, the predominating colors would comprise earth tones mixed with ochre. This same landscape after a rain would require the palette to take on some greens. Likewise, the atmospheric color of

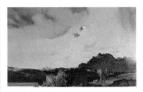

Fall landscape.

Winter landscape.

a mountain during the dry season takes on warmer tones. In the wet seasons, the earth becomes fertile, the copper tones return, and the earth colors on the palette are substituted with lively greens that acquire darker hues as they develop and thicken.

The Cool Palette

A landscape can be painted during any season of the year with any of the known harmonic ranges, but it must always have a dominant, basic color; something that is determined by the subject itself.

The harmonic range of cool colors is employed for cold subjects; nonetheless, that does not mean that warm colors are automatically excluded, providing that they don't come into conflict with the dominant tone.

In general, the cool-colored elements of a landscape comprise the sky, the foliage, the terrain, and the shadows. The painter must bear in mind that in a landscape of a cool tendency there is also a tonal relationship between the planes. The greater the distance the more the colors tend to green and blue and the scarcer the warm tones are.

Summer landscape.

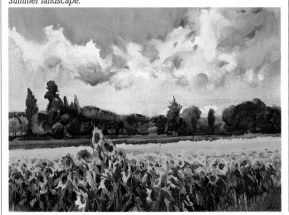

Painting with a cool range of colors.

Cool hues incorporated to the tree's shadows.

The Warm Palette

Warm colors have their value in hot, humid landscapes where there is an abundance of earth, or in dry dusty land-

The cool colors are applied throughout the entire painting.

scapes in which the sun is very intense.

Composed of red, earth color, ochre, and brown, the warm harmonic range of colors represents within its chromatic possibilities a wide tonal range that mixes well with cool colors.

In the same way that cool colors become cooler with distance, warm tones appear less bright. You can modify the brilliance of warm colors by adding white and pale earth colors such as ochre. As regards shadows, they contain hues of red in the foreground, becoming brownish in the more distant planes.

MORE INFORMATION
The sky and its color **p. 80**

Pastel landscape using the warm color range.

The Neutral Palette

Mixed colors are excellent for painting landscapes in the fall and in those climatic conditions where subdued neutral colors predominate. Neutral colors are obtained by mixing two complementary colors in unequal quantities plus white. The result of such a mix is neither a cool nor a warm color, but a subdued harmonious color. This chromatic range can incorporate colors from the other two ranges, both directly and in mixtures, since in this way colors having opposite qualities are combined and thus neutralized.

The painting of planes with a mixed range is carried out by increasing the amount of white for the farthest planes, along with a slight increase of cool colors, while in the foreground a warm tone dominates.

A neutral-range landscape.

Ideal Mediums

Both oils and watercolors are ideal mediums for painting seasonal landscapes; on the one hand, thanks to their opacity, oils permit the creation of dense and contrasted areas, allowing changes to be made at any time during the session; watercolors, on the other hand, are excellent for fast sketches, since their wet character enables color blends to be carried out on the paper in transparent washes.

*Eugene Boudin,
Dusk in Summer*

Planes in the Sky

In this study of the sky, Eugene Boudin painted the scene in pastel. The planes separating the clouds in the background are clearly distinguished by the blue hues and by the bright parts of the clouds.

TECHNIQUE AND PRACTICE

A CLEAR SKY

In landscape painting, the sky is one of the most important elements, since it completely influences the rest of the objects in the painting.

It is essential to have a firm grasp of color theory in order to apply it correctly when painting the different planes of the picture. In the following chapter, you will see that a clear sky is not a flat unbroken stretch of color, but a series of changes in chromaticism, luminosity, and depth.

A sky palette.

Variety of Tones

At first, the execution of a clear sky may appear to be an easy task; nonetheless, when painters begin to create a desired atmosphere for a specific climate, they have to allot the colors required on the palette.

The colors that are used are determined by the type of sky in the subject, which could consist of the following:

• A midday sky over a dry landscape contains white, cerulean blue, ultramarine blue, red, and Naples yellow.

• In a sky over a dark green landscape you would need white, cerulean blue, cobalt blue, and green.

• The colors for painting a sky at dusk would comprise white, cerulean blue, cobalt blue, red, and yellow.

Different gradations of cool and warm tones.

Color Gradation

When you paint the sky in a landscape, be careful which colors you choose in that the sky usually has an influence on all the adjacent colors. You might begin with a pale, almost uniform color, leaving in reserve only those areas that you do not wish to change too much and might be difficult to handle, such as the pure raw whites.

After the initial color application, you may incorporate

the hues you have been mixing on the palette. It is up to you to decide on whether to apply loose sweeping brushwork or carefully blend the new tones with the background color directly.

Superimposing forms on a background.

Finishing the forms.

Blending the color between the trees and the color of the sky.

Variety of earth colors (left group), all of which can be used in the sky. Different cool colors are shown in the right group. Gradated colors are ideal for the tonal variations in the sky.

Relationship Between the Landscape and the Effects of Color

In a colorist or expressionist painting, the brushstroke and the color play a fundamental role. All the colors in the picture must be related to one another in as loose and intuitive a manner as possible. This means that the mixing of paint takes place directly on the canvas, and thus the sky will take on the colors of the landscape. In this almost visceral way of working, the artist disregards the colors in the subject and directs his or her efforts based on the relationship between the colors themselves. For example, the artist may paint a cobalt blue sky in order to create a contrast with a green background, or decide on yellow and violet so that a vibration of complementary colors can occur in the landscape.

Van Gogh, Strollers in a Public Garden in Asnieres *(detail).*

Maximal Points of light

The most brilliant areas of a plane are produced in part by the inherent color of the objects and the light coming from the sky, which in turn has its own luminous variations. As the sky you are painting gets closer to the sun, it takes on whitish tonalities. This area has to be blended very carefully, gradually adding white and possibly changing the tones with tiny touches of Naples yellow, taking care to prevent the mix from becoming greenish.

The intense blue color added to the sky creates a contrast that highlights its most brilliant parts.

MORE INFORMATION
Climate and color **p. 84**

Brushwork in the Sky

The artist can create the effect of depth in the sky by means of color gradations emphasized by the brushstrokes. Wide brushes are generally used for blending, soft stroking of the canvas, and mixing the colors with a barely noticeable gradation. This type of brushwork can also be carried out with watercolors, provided the paper is not too wet.

On the other hand, more resolute brushwork can be employed, adding new paint without blending the colors, creating both horizontal and oblique planes, varying the direction of the brushstrokes, and employing different styles of brushes.

Warm Colors on the Horizon

The horizon line is the area where sky and earth meet. The sky may require some color changes if you want to provide the horizon with more depth, or even to emphasize the contrasts in the landscape. If you want to obtain the effect of a torrid summer sky, you will have to add warm colors in gradation from the upper sky to the horizon line.

Cobalt blue

Ultramarine blue

Prussian blue

Adding warm colors to blue.

Blending brushstroke.

Loose brushstroke.

TECHNIQUE AND PRACTICE

RAIN: TECHNIQUES, CHROMATICISM, AND HIGHLIGHTS

After a storm colors become saturated; objects that before the rain looked dry, now take on a smooth, varnished appearance. The surface of a landscape undergoes similar changes with respect to its dry state; the ground becomes dotted with puddles, the leaves of the trees sag under the weight of the rainwater, and rocks turn into tiny sparkling mirrors.

Saturation of sky colors reflected on the water.

Chromaticism and Highlights

Whenever an object becomes wet, its color becomes purer, that is, the object takes on a darker tone that emphasizes its local color and brings out details in areas that come into contact with the water. These effects are translated to the palette by an increase of browns and reds. Tree trunks become dark green and blue, while the closer ones take on heightened browns. All the colors increase in brightness due to the cleansing of the atmosphere.

The surface of a wet object emits reflections in the form of specific points of light. Their tonality and brilliance depends on how wet the object is and on the porosity of its surface. The highlights of an object correspond to the brightest color on our palette. In the case of watercolor, highlights are created by reserving white areas on the paper. This can be achieved by applying some wax over the area you wish to leave white.

Effect of Wetness in the Trees

A landscape appears to change after a storm. The trees change both their color and their shape. If you study a tree carefully, you will notice how,

On humid days, tree leaves trap water and luminosity increases.

depending on the foliage and thickness of the leaves, it gives way to the weight of the water; with the exception of evergreen trees, the foliage of most trees appears to sag slightly under the weight of the rainwater.

The color of rain-drenched trees tends to appear uniform with distance. In this case the watercolor medium captures the different tones of greens in the middle planes, differentiating the last plane of trees in the background.

Study of a Rainy Sky

A rainy sky is normally dark and lead-colored. Nonetheless, unlike a clear sky, a rainy sky is filled with bright streaks of rain. The palette colors for a rainy sky are white, cerulean blue, cobalt blue, and gray.

Wet branches tend to sag under the weight of the rainwater.

In puddles, water produces reflections that originate from the brightest areas.

When painting a drenched terrain, the artist must create gradual differences between light areas (highlights) and areas in shadow. The water in the puddles is illuminated by its brightness.

The darkest areas in contact with the lightest areas create a strong contrast, which calls for lighter tones always within the same luminosity level. Highlights cover a wide palette range, from natural shadow to blues.

The Rain Palette

Color also changes, especially in the upper reaches of the trees, since the lower areas have been protected by them.

The palette colors will include emerald green, permanent green, alizarin crimson, Prussian blue, ultramarine blue, ochre and yellow. The effect of rain influences all of the elements in a landscape.

Highlights

Highlights are tonal variations or points of light. These lights vary according to the tone of the object and to the incidence of light. A palette for painting highlights comprises all colors, since it is the effect of simultaneous contrast between colors what indicates a specific highlight; for instance, shiny points can be highlighted on a brown surface by using raw umber, ochre, and white, which will provide the painter with the scale of values needed.

Reflections in Puddles

The reflection of objects in puddles can be seen by the artist when they are located in the plane he is painting.

Refections tend to reproduce the color of the object reflected, although the shape itself appears deformed by the movement of water. The contrast of the puddle with the terrain increases and must also be defined by in-

creasing in this area the points of light that the waves produce in the water.

Reflections do not work in the same way as shadows, which are cast horizontally over the ground. The reflected object tends toward verticality, as if it were a mirror.

A rain-drenched landscape painted in wash. The reflections in the puddles have been executed with a variation of grays without any black.

Detail of a sketch drawn in pencil of a wet landscape. The reflections in the puddles have been painted with great detail.

MORE INFORMATION

The sky and its color **p. 80**

Climate and color **p. 84**

A stormy sky **p. 90**

A STORMY SKY

The moment just before a storm has been the subject of many notable paintings. The representation of the force of nature in a landscape continues to be one of the most challenging themes for the landscape artist.

Composition, color, and contrast are the main factors to bear in mind, realizing that all the elements that form the whole influence one another, whether by tonal or chromatic contrast or by the masses that they occupy in the painting.

The Importance of Space

When we paint a landscape, we first have to decide what proportion of it will occupy what space in the painting.

Perhaps you choose to give more importance to the stormy sky and include only a small portion of the landscape. In this case the horizon line is so low that only a small strip is left as a reference for the terrain over which the sky is situated. The task of dividing up the space when you are composing the subject will provide you with a guideline to follow, that is to say, if you choose a vertical format and place only a quarter of the landscape within it, the end result will be a painting in which the sky is most important. A stormy landscape is one subject that fits perfectly within this type of composition, attempting to capture the vastness and force of nature through the drama of the sky.

A monochrome work allows the artist to study the maximal points of light in the sky.

In a watercolor painting the highlights in the clouds are left to last.

The variation of grays increases brightness.

Chromatic and tonal evaluation. Painting a stormy sky requires alternating a variety of contrasts.

Monochrome, Transparent, and Opaque Properties

The task of capturing a storm begins with an almost homogenous painting and very often requires direct, unmixed palette work on the canvas. A medium bluish gray is an appropriate tone to cover the entire sky with, except for the masses that are to be left almost white.

In the case of watercolor, masses such as these zones of maximal light are left in reserve, and the rest of the sky is painted in layers, using wet and dry paper techniques so that the blends can be obtained either by previously prepared mixes or by running the brush over the wet zones.

A monochrome work of grays determines the lightest and darkest areas. If the paint is fresh, some circular brushwork can be applied to the subject to create the shapes of the clouds; once the paint is dry, several transparent layers can be added to enhance the color.

Influence of the Sky on the Earth

You will already have seen in earlier chapters how the sky meets the earth, to such an extent that occasionally only the stormy clouds of the landscape are visible.

As the light fades and the sky loses its brightness, the land gradually loses its contrast and takes on a unified appearance, akin to a mass in which it is only possible to make out the main forms and the most intense highlights.

The palette used for painting a landscape depends to a great extent on the color of the sky and the harmonic range chosen.

Any type of palette is suitable for executing a land-

The color of the sky influences the landscape.

The horizon increases the presence of cool tonalities.

Highlighted zones often require the use of a palette knife or your fingers. It may have a yellowish tendency.

Areas in shadow call for light gray mixed with the same blue of the sky.

Clouds sometimes appear very dense and with deep shadows.

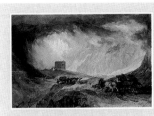

Turner, Landscape of Mount Cenis.

Contrast in a Storm

This is a perfect example of a stormy sky painted in watercolor. The effect of the force is dramatized thanks to the strong contrast obtained between the lights and darks.

scape, but whatever the case, you must always bring out the maximal contrasts.

The Highlights in the Clouds

Having established the basic chromaticism of the sky, the artist can identify the brightest parts; then the painter applies the darkest areas, which tend to coincide with the accumulation of clouds and of the shadows among them. The clouds should be outlined in a dark color using a round brush and be blended with a circular movement in a gradation toward the deepest color.

Areas of reflected light present a paler gray with an extremely slight bluish or yellowish tendency.

Once the darkest areas have been indicated, the brightest parts are highlighted in the same way as the shadows. The lines or masses that connect the areas of shadow with those in the light provide important contrasts within the composition.

Volume in Clouds

A broad sky is a large surface on which objects are located in depth just like on the land; therefore, clouds also have to be located according to the rules of depth and perspective.

A strong storm provides a foreground rich in contrasts and large tonal masses. The farther away we are the smaller the volumes tend to be. On the other hand, a gentle storm will never produce this effect.

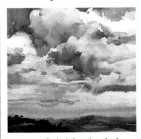

By heightening the lower clouds, it is possible to achieve a highly dramatic result.

TIPS FOR PAINTING SKIES

No two skies look alike. So there is no unique formula for painting this element that plays such an important role in a landscape. If the painter knows the medium and other material he or she is going to paint with, both the procedure and the result can be very pleasing.

Old Brushes

Brushes are the painter's most important work tools. An artist is well aware that it is vital to keep his brushes in good shape. This does not mean to say that once these cherished tools have become too old and worn they should be thrown away.

A worn or damaged brush can be used for removing paint from the canvas without leaving a mechanical-looking trace; such brushes are also very useful tools for creating stormy skies, and blending and mixing colors on the canvas itself.

Wide brushes are excellent for covering broad surfaces, even when the finished painting will involve a lot of detailed work. Fine-hair brushes are ideal for painting gradations on uniform surfaces without leaving any bristle-like texture.

Frottage

A hard hog's hair brush can be used for painting smooth flat skies by scrubbing over the surface of an already dried underpainting, but allowing some of the underlying color to remain visible. This brush is especially useful in rendering clouds and blending the colors along the horizon line. This *frottage* technique can be applied with both oil and acrylic mediums, the latter having the advantage of fast drying. The brush should be lightly loaded with paint; in fact, it is advisable to rub the loaded brush over the palette in order to remove most of the paint.

The brush should be lightly loaded with paint to scrub on top of the dry base color.

These different styles of brushwork emphasize the cloud's texture.

Circular Strokes for Painting Clouds

Clouds can be painted over a previously painted color base by applying some white to the canvas and then spreading it with a circular motion until it has blended with the base color. Small amounts of white paint should be applied in spirals leading inward in order to bring out the shapes of the clouds. Then a wide brush is used to lightly soften the edges of the clouds while at the same time defining the clouds' plane.

You begin with a freshly painted base color.

Old brushes.

Light and Indistinctness

In this painting, the artist creates a scene including both night and day; possibly the result of backlighting. The bright sky makes the shapes of the trees stand out like silhouettes against the background. The backlighting effect is excellent for dramatizing the sky.

Magritte, The Empire of Lights.

A continuous circular sweeping motion is carried out with the brush.

A wet base color allows you to continue to blend in other colors.

Using darker hues, the painter energetically performs some twists with the brush to create contrast.

Once the clouds have been correctly positioned, we can begin working in the additional color.

MORE INFORMATION

The sky and its color **p. 80**
Climate and color **p. 84**

A glaze is a fine layer of almost transparent paint that lends the picture chromatic unity and depth. This is done by applying a very small amount of paint to a mix of 50% turpentine and 50% oil painting medium. The same applies for acrylic paint, except that the mix is made up of water and acrylic medium.

The Uniformity of the Sky

Sometimes a painted sky does not require much elaboration, perhaps because the subject itself does not demand it, or because the landscape is so prominent that the sky requires only some chromatic association with the ground.

A midday sky can be painted with a mix of white, cobalt blue, and cerulean blue (a larger proportion of the latter). The resulting color is then applied with a wide brush.

An afternoon sky has some warm accents within its otherwise blue uniformity. In order to create a uniformity of color and texture, the strokes must be softly and successively applied in a horizontal direc-

The paint is applied in an even manner.

The tiny hues of color are blended with the background.

tion, blending one stroke with the other.

Color Blending

The blending of the colors in the sky is very important,

A clear sky can be heightened with warm tones in order to accentuate the depth on the horizon.

since the gradation of the color and the inclusion within it of different hues helps to create realism and depth.

Small brushstrokes of chromatic variations, both complementary colors and tonalities from the same harmonic range, can be added to a fresh undercoating. The color can be blended into the background by carefully applying successive strokes over the background color.

This step of blending in a final application, or glaze, provides the picture with a chromatic coherence. The final glaze must not be painted until the painting has completely dried.

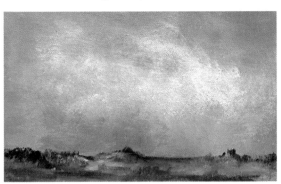

TECHNIQUE AND PRACTICE

HOW TO PAINT FOREGROUNDS

When you are planning your landscape, it may happen that, on more than one occasion, you choose an interesting viewpoint, only to find that some pictorial and compositional problems arise in the foreground. Painting is an art that offers infinite creative possibilities; therefore, you should try every possibility that you can think of. For example, you may want to remove a house from the scene or include some trees or flowers. Why restrain yourself?

Essential Objects: Trunks, Rocks, Trees

It is important to be sure of the location of the planes when you decide on the framing of your picture. First draw two horizontal lines to mark the foreground, middle ground, and background. Because the

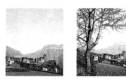

By slightly altering the viewpoint, you can radically change the whole composition.

main function of these lines is to separate the three planes, there is no need to include anything else at this stage.

Once you have roughed-out the canvas, indicate which objects will comprise the foreground. You don't have to paint an exact copy of the subject; in fact, you may even want to include objects located outside of the composition. However, always bear in mind the direction of light.

The placement of the objects is drawn in the same way as is the rest of the painting, superimposing them throughout the background planes.

Composition and the Foreground

Composition is the key factor in landscape painting. The artist should achieve a balance of all the elements within the picture area.

Visually, the masses of color in a landscape have different weights depending on which plane they occupy. Therefore you must pay special attention to developing an adequate foreground by playing down the dark areas and reducing the large shadows. By increasing the use of transparency you will gain more color depth, particularly in the background planes.

Here are two possible solutions:

In a triangular composition, situate the points of light in the top half, especially when it is in combination with leaves.

Limit any excess of lines going in a single direction by placing other compositional elements in opposing locations.

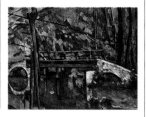

Cézanne, The Bridge at Menney. The points indicated in the scheme show the main areas where the planes overlap each other.

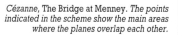

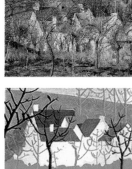

Pissarro, The Red Roofs. Notice in the scheme how the foreground helps to give depth to the successive planes.

Determining the Amout of Blending

A landscape has a specific depth of field; when we look at the horizon, our eyes no longer focus on the details of the shapes in the foreground, although we are still aware of their color. If you paint a landscape in depth with a highly detailed foreground everything will appear in sharp focus, while the more distant planes will, in contrast, lose their details. On the contrary, if we omit details in the foreground, the planes will appear more separated and the observer's eyes will be drawn directly to the painting's center of interest.

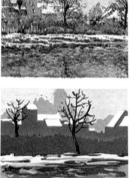

Van Gogh, Hill with the Ruins of Montmajour.

Van Gogh and the Foreground

In this landscape, the great master included a large rock in the foreground, while at the same time allowing an excellent distribution of the remaining masses around it.

Monet, Effect of Snow. *Note how the absence of details in the foreground does not distract the spectator's attention. This plane occupies almost half the painting, also providing it with depth.*

The palette knife is also good for painting leaves, even in pictures painted entirely with the brush.

Detailed Work

If you decide to paint a highly detailed picture, you will have to take pains in the rendering of the highlights, shadows, and textures of the foreground, ensuring that their tones are different from those in the rest of the picture. If you have painted the tones of the textures (shadows, highlights) in the distant planes with one homogenous color, you should treat the elements in the foreground with related tones.

Chromatic wealth and variety in a small area.

Once the foreground has been painted, you should play down its presence by blending the adjacent colors with a clean, dry, wide brush. A slight reduction in the size of the forms in the background will contribute to the depth of the composition as a whole.

Each plane in the painting should be given its own unique treatment with the paint.

The Use of the Palette Knife and the Tip of the Brush Handle

The palette knife is ideal for working on the foreground, in order to create textures and carry out *sgrafitto* (scratching) with the tip.

The tip of the palette knife also comes in handy for paint-

A worn brush is used to apply texture.

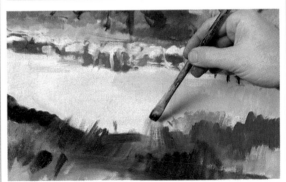

ing grass and other textures in the green masses of the foreground, simply by scratching away some of the most recently applied paint in order to allow the underlying colors to be seen through.

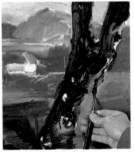

Creating texture in the bark of a tree.

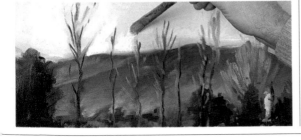

MORE INFORMATION

Trees in the landscape **p. 50**
Rocks in a landscape **p. 60**
Different planes and depth **p. 76**

Original title of the book in Spanish: *Paisaje.*
© Copyright Parramón Ediciones, S.A. 1996—World Rights.
Published by Parramón Ediciones, S.A., Barcelona, Spain.
Author: Parramón's Editorial Team
Illustrators: Parramón's Editorial Team

Copyright of the English edition © 1996 by Barron's
Educational Series, Inc.

All inquiries should be addressed to:
Barron's Educational Series, Inc.
250 Wireless Boulevard
Hauppauge, NY 11788

International Standard Book No. 0-8120-6616-2

Library of Congress Catalog Card No. 96-85273

Printed in Spain
987654321